# NEW CERAMIC SURFACE DESIGN

## SURFACE DESIGN

Learn to Inlay, Stamp, Stencil, Draw, and Paint on Clay

 molly hatch

**Quarry Books**
100 Cummings Center, Suite 406L
Beverly, MA 01915

quarrybooks.com • www.craftside.net

© 2015 by Quarry Books

First published in the United States of America in 2015 by
Quarry Books, a member of
Quarto Publishing Group USA, Inc.
100 Cummings Center
Suite 406-L
Beverly, Massachusetts 01915-6101
Telephone: (978) 282-9590
Fax: (978) 283-2742
www.quarrybooks.com
Visit www.craftside.net for a behind-the-scenes peek at
our crafty world!

All rights reserved. No part of this book may be reproduced
in any form without written permission of the copyright
owners. All images in this book have been reproduced
with the knowledge and prior consent of the artists
concerned, and no responsibility is accepted by the
producer, publisher, or printer for any infringement of
copyright or otherwise, arising from the contents of this
publication. Every effort has been made to ensure that
credits accurately comply with information supplied. We
apologize for any inaccuracies that may have occurred
and will resolve inaccurate or missing information in a
subsequent reprinting of the book.

10 9 8 7 6 5 4 3 2 1

ISBN: 978-1-63159-028-3

Digital edition published in 2015
eISBN: 978-1-62788-336-8

Library of Congress Cataloging-in-Publication
Data available.

Cover and book design: Laura McFadden Design, Inc.
Photography: Thea Coughlin

Printed in China

*For all of my teachers along the way—thank you.*

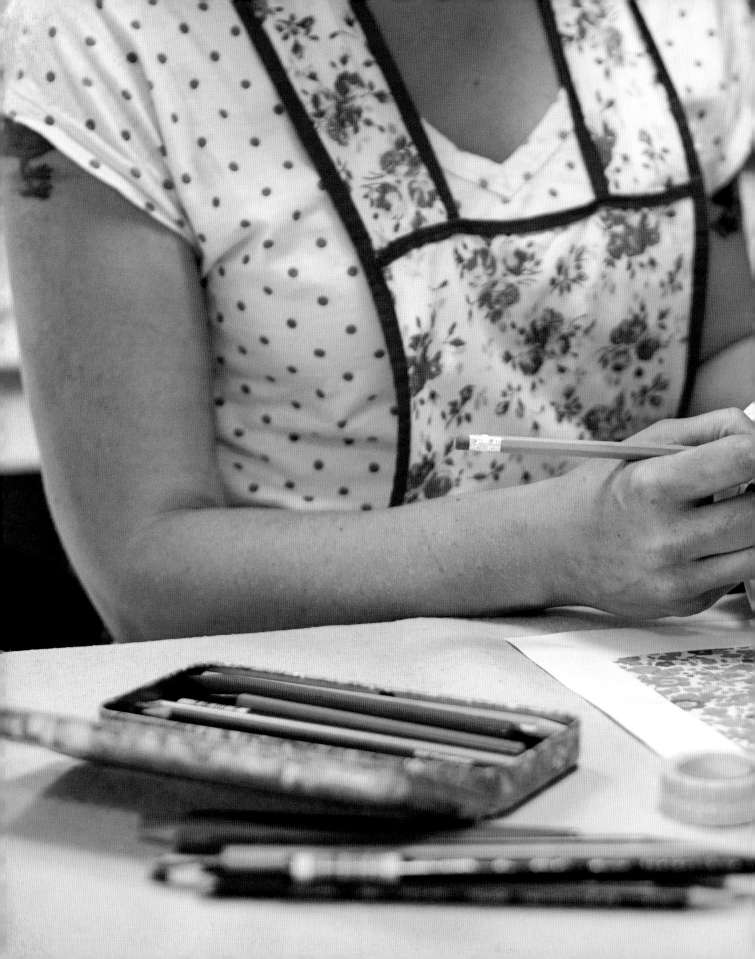

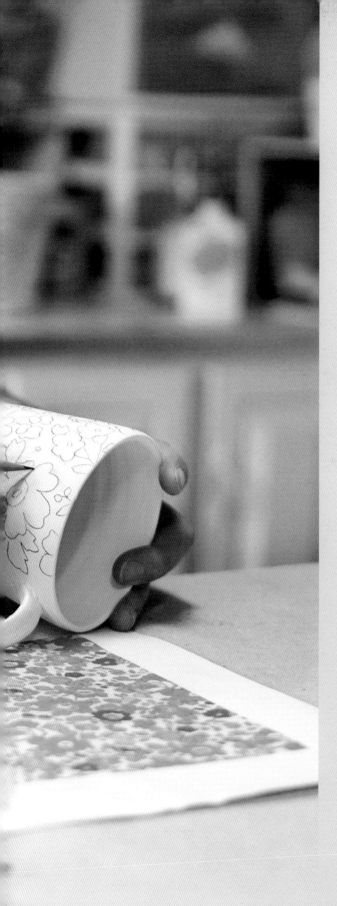

# CONTENTS

IIIIIIIIIIIIIIIIIIIIIIIIIIIIIIIIIIIIIIIIIIIIIIIIIIIIIIIIIIIIIIIIIIIIIIIIIIIIIIIIIIII

# INTRODUCTION

Often in ceramics we get through the stage of creating a form and are stumped by how to finish it. For most of us working in clay, the task of learning how to make forms is our first major focus in the studio. It is usually after we develop enough skill in making forms that we begin to explore the ceramic surface—and this can be overwhelming!

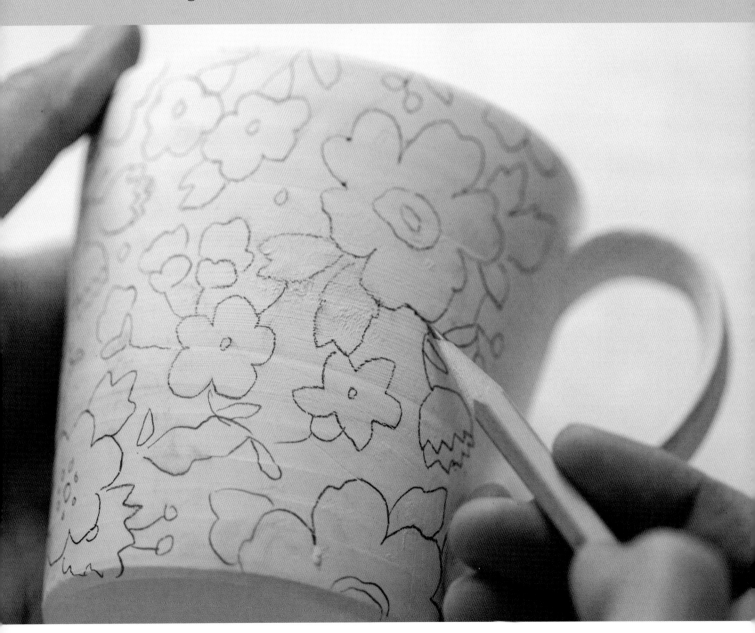

For a long time, I made pots with very little surface decoration; adding stamped texture was perhaps my first attempt at a decorative surface. But my approach was forever changed when one of my favorite undergraduate professors taught me how to add the drawings I was making on paper to the surfaces of my functional pots. With this discovery, I caught the ceramics bug. Since then, I have been enchanted with the ceramic surface as a canvas, and my love of drawing and painting patterns and of graphic imagery has become the focus in my ceramic work.

I wanted to write this book to encourage those of you who long to create more complex surfaces on ceramics but haven't yet found the right technique. On these pages, I have brought together a variety of surface techniques that use simple tools and materials and require only a clear glaze to finish. Although this book assumes you are skilled enough to make forms to decorate and that you have a basic knowledge of the ceramic process, it still provides an introduction to the ceramic surface. And, because this is a workbook designed for those with multiple levels of experience with clay, I have tried to make this book easy to use. Not all of us are comfortable drawing and painting so I've included templates of the artwork I used to make the projects, allowing you to replicate the techniques without the stress of creating your own artwork.

You will find a wide range of surface techniques for everything from greenware to bisqueware. For simplicity's sake, all of the projects in this book use underglaze or slip to add color and a basic clear or tinted glaze for finishing. Sticking to basic glazes allows us to open up to the possibilities for surface decoration at multiple stages of the ceramic process.

My initial love affair with the ceramic surface began with the sgraffito carving process. The sgraffito technique allowed me to achieve a woodcut look on the clay surface. As my work grew and changed, I wanted to achieve a finer line quality in my ceramic surfaces. I adopted the mishima slip inlay technique when I discovered that it allowed me to draw on clay in much the same way that I draw on paper. Mishima has become the technique that I use most often and is what gives my work a distinct line quality and look. I often use mishima in combination with many of the other techniques in this book. I learned many of these techniques from my college professors, from taking workshops, or from friends and colleagues. While many of the techniques are traditional, I have adapted the methods and tools to make and design my own unique ceramic artwork.

New Ceramic Surface Design is organized into six chapters. The first three help you gather tools and inspiration for your projects. Finding inspiration and gathering imagery to work from is a large part of surface design and often challenging. I discuss how to make forms that are good for surface pattern and basic compositional techniques for applying surfaces on three-dimensional forms. Chapters 4, 5, and 6 include surface decoration projects and tips—chapter 4 focuses on projects using line, chapter 5 on texture, and chapter 6 on shape. The Glossary defines many of the basic terms related to the surface projects in this book. The Recipes section includes the recipes I use most in my own studio practice so that those of you who have access to glaze labs can mix your own. The Resources section lists where to find many tools and materials as well as commercial glazes, underglazes, and stains.

The end of each project includes artist inspiration pages, with images from some of my favorite artists who use the techniques demonstrated. The work of these artists, who range from emerging to established, provides an exciting way for me to share how other artists apply the same techniques to their ceramic surfaces. I hope their work will inspire you to open your mind to the possibilities for your own new ceramic surfaces.

Consider this book a launching pad for finding your own expression through surface decoration. I hope this book will serve as a resource for beginners and an inspirational reference for more established ceramists. What excites me about it are the infinite possibilities for new ceramic surfaces within it. I love decorating my work, and I know you will, too. In fact, I can't wait to see what you create! I encourage you to modify the projects, make new tools, and adapt the techniques for your own needs. With each piece you decorate, I hope that you will develop new ideas for what to make next, ideas that you will incorporate into your work for a long time to come. Most of all, I hope that this book shares my love of the ceramic surface. Pass it on!

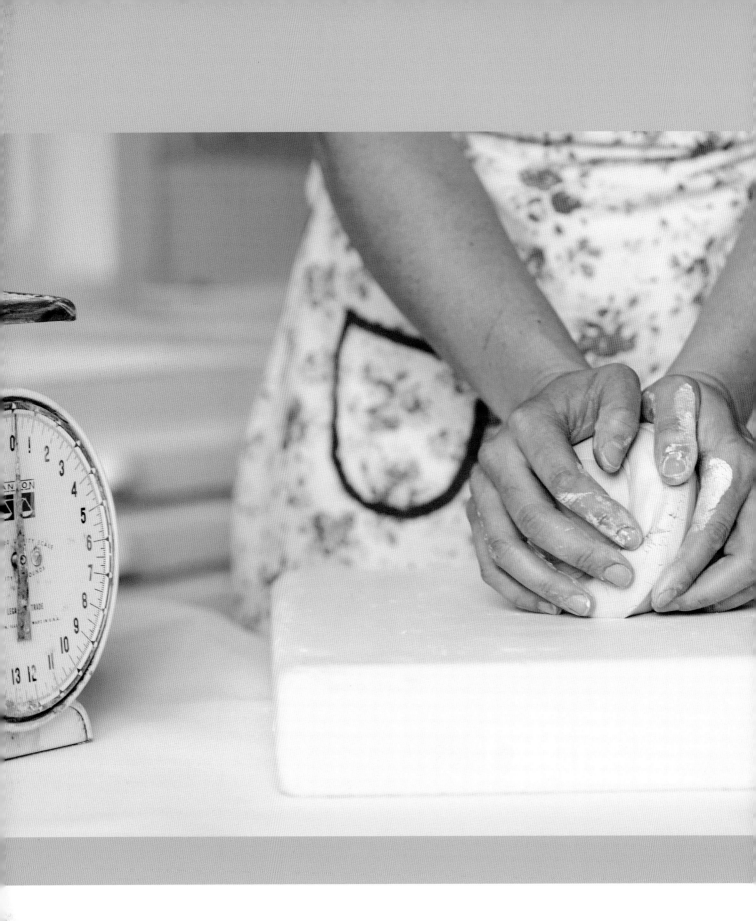

# GETTING READY

||||||||||||||||||||||||||||||||||||||||||||||||||||||||||||||||||||||||||||||||||||||||||||||

From choosing the right clay to selecting the perfect paintbrush, this chapter will help you gather the right materials to begin the projects in chapters 4 through 6. This book assumes you have access to a basic ceramics studio and that you have a basic knowledge about making ceramics. While I chose to use porcelain in the projects shown in this book, you may find that you are more comfortable with another clay. Please adapt the projects to your own studio practice and experiment

with the projects to incorporate them into your existing practice. Remember, whenever you try a new material, please be sure to test it on a small sample before completing the main project!

Having the right tools and materials can make all the difference in ceramics. In these pages, I'll list the tools I prefer and explain why they work best for me. And I'll walk you through some of the more common problems that can come up with each project and provide tips on how to solve the problems on your own.

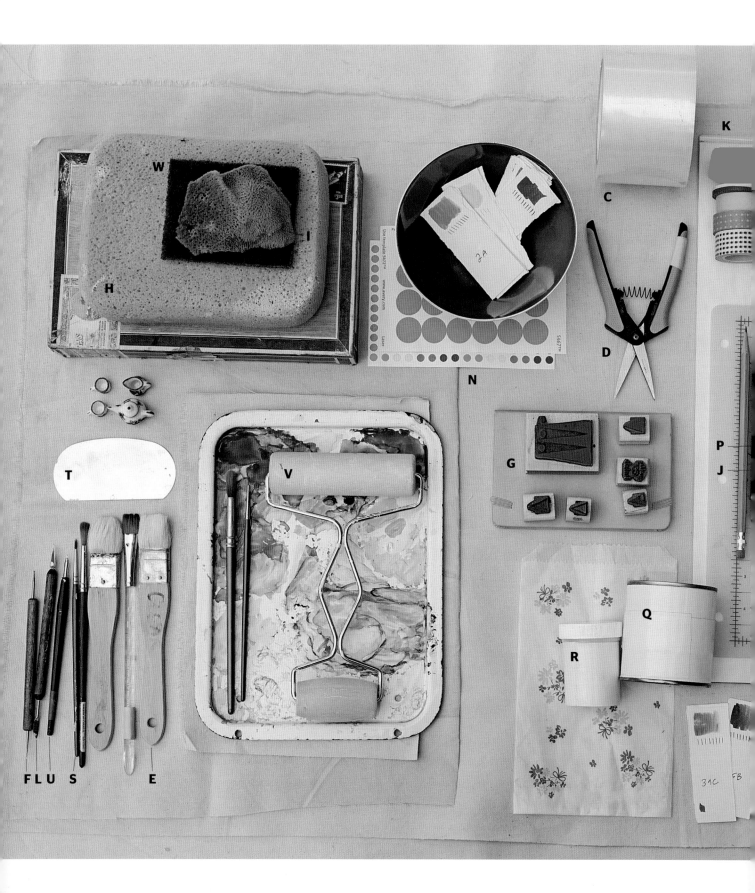

# GATHERING TOOLS

Many of the projects in this book require the same tools, and some require tools specific to the individual project. I have listed the tools that have become my favorites for creating the surface techniques in the projects—my tried-and-true tools that I always use. With each project I will suggest which tools to use from this master list, but it's important to experiment with your own tools as well. When I first learned how to do the mishima slip inlay technique, for example, I was taught to use a pen-style craft knife to make the mark. But the mark that the craft knife made was angular, and I wanted the tool to make marks that were smooth and calligraphic. So I experimented with other tools and finally ended up with a calligraphy pen and nib instead. It gave me the exact line quality I was after. So be an opportunist and try unconventional tools in clay. You never know what might become your favorite!

**A** tracing paper
**B** transfer paper
**C** clear packing tape
**D** scissors
**E** 1" (2.5 cm) hake brushes
**F** ball-tipped stylus
**G** rubber stamps
**H** synthetic sponges
**I** natural sea sponge/elephant ear sponge
**J** underglaze pencil
**K** washi tape
**L** spear-tipped carving tool
**M** contact paper
**N** dot stickers
**O** self-healing cutting mat
**P** craft knife
**Q** shellac
**R** denatured alcohol
**S** small round watercolor brushes in a range of sizes
**T** metal rib
**U** calligraphy pen and hard nib
**V** brayer
**W** green kitchen scrubbing pad

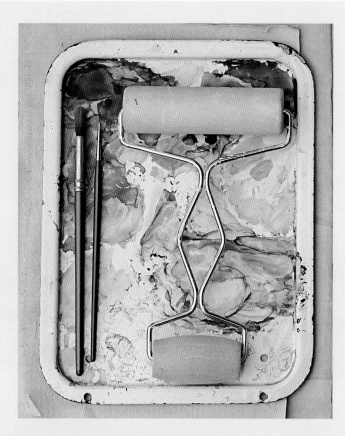

## » Tracing Paper

Ceramic surfaces vary in size and can require odd sizes of transfers, so it is nice to have large-scale tracing paper, such as Strathmore's 14" x 17" (35.5 x 43 cm) tracing pad.

## » Transfer Paper

I use Saral Red. It's great for transferring imagery because it is erasable on paper and on the bisque ceramic surface and it is wax-free. Graphite paper and carbon paper can also work, but sometimes they contain wax. When working on a bisque ceramic surface, this wax sometimes resists the glaze you apply over your decoration, which is not good! Experiment and use wax-free paper.

## » Clear Packing Tape

I use 3" (7.5 cm)-wide clear packing tape that is inexpensive and lightweight to laminate my tracing paper transfers. Heavier packing tape is great for shipping boxes of ceramics, but it is too thick for laminating your transfers.

## » Scissors

I always have several sizes of scissors in the studio. There is nothing better than a pair of good, sharp scissors!

## » Three Soft Brushes

I use 1" (2.5 cm) hake brushes, which are soft and inexpensive. You'll want to use one clean and dry brush for brushing "crumbs" when carving or drawing into leather-hard clay. A second will be used for applying underglaze or slip to your work. And the third should be dedicated to use with clear glaze only so as to not contaminate the glaze.

## » Ball-Tipped Stylus

I prefer the AMACO T-3 stylus. I use it for transferring imagery onto the leather-hard ceramic surface as well as onto the bisque ceramic surface. It leaves a clean, hard line.

## » Rubber Stamps

Keep a wide variety of rubber stamps on hand that you don't mind using in ceramics. Stamps can be used to great effect for multiple projects in this book and may serve as a source of inspiration. Look for new stamps when you are at a craft store, and remember that letter and number stamps can be fun, too!

## » Synthetic Sponge

I find these in the automotive section at the local hardware store. They are made for cleaning cars, but come in handy for most everything in the studio, from making stamp pads to cleaning the glaze off the bottom of a pot.

## » Natural Sea Sponge/Elephant Ear Sponge

Although these are a natural resource, I have yet to find a synthetic replacement. These sponges are amazing for specific projects—namely mishima slip inlay. I have only had success with mishima using an elephant ear sponge. These are the larger, softer sponges, not the denser, harder sponges. The harder sponges will leave marks on your work. The softer the better!

## » Underglaze Pencil

I use AMACO underglaze pencils all the time in the studio. They come in many colors, but black is perhaps the most multifunctional of all the colors, so if you only invest in one, get black!

## » Washi Tape

Washi tape is a waxy paper tape that isn't overly sticky— a cousin to drafting tape. Use washi tape when masking because it is thin and adheres without any residue. Use washi tape to adhere tracing paper to source imagery, because it won't damage the paper when it is peeled off. I use washi tape to secure my transfer image with Saral transfer paper beneath to a bisque piece as well. So many uses!

## » Spear-Tipped Carving Tool

This is a great tool for carving the ceramic surface. I also use the pointy tip to remove stickers from bisque when doing the sticker resist project.

## » Contact Paper

I prefer black contact paper because the contrast makes it easier to work with. I was able to buy a huge roll very inexpensively online. With contact paper, it's easy to make your own stencils and stickers.

## » Dot Stickers

The various sizes of pricing dot stickers that you can get at almost any office supply store are fantastic for making the perfect polka dot pattern.

## » Self-Healing Cutting Mat

An 8" x 10" (20.5 x 25.5 cm) mat is often big enough for cutting out small things. It is definitely worth keeping one on hand for protecting your studio surfaces.

## » Craft Knife with Replacement Blades

A pen-style craft knife is an important tool in any studio. I use this tool for cutting stencils and making my own sticker resists out of contact paper. It is also handy for cutting washi tape.

## » Shellac

This is great for using as a resist. Buy a small container, because a little bit goes a long way. Also avoid water-based shellac, which doesn't work as well.

## » Denatured Alcohol

This will clean the shellac off your brushes and preserve them. Wash brushes immediately after using shellac, because shellac dries fast.

## » Small Round-Tipped Watercolor Brushes in a Range of Sizes

Here is where your personal preference comes into play. It's great to use watercolor brushes when painting on the surface of ceramics to achieve a brushstroke similar to watercolor. The brushes are expensive and tend to get "sanded" down by the rough surface of ceramics, but it's well worth it for the line quality they offer. Experiment to find the ones that work best for you. The brush I use most often is a round tip size "0."

## » Metal Rib

There are so many uses for this handy tool, but most of the time I use mine to scrape glaze.

## » Calligraphy Pen and Hard Nib

I use the Speedball Hunt 107 cartoonist's nib and the pen it fits into. This is the hardest nib I can find. Most nibs are soft, and they will split when you are drawing into the leather-hard clay, leaving a double line rather than a single line.

## » Brayer

I love my ceramic brayer tool! With a rounded edge, it pushes texture into the surface of clay nicely. Alternatively, you can use a lacrosse ball or squash ball and roll that over the surface of the clay.

## » Green Kitchen Scrubbing Pad

Use this to clean up the edges of work when stamping and to sand down the burrs on sgraffito when pots are bone dry and about to go into the bisque kiln. Remember safety when sanding ceramics and wear a dust mask!

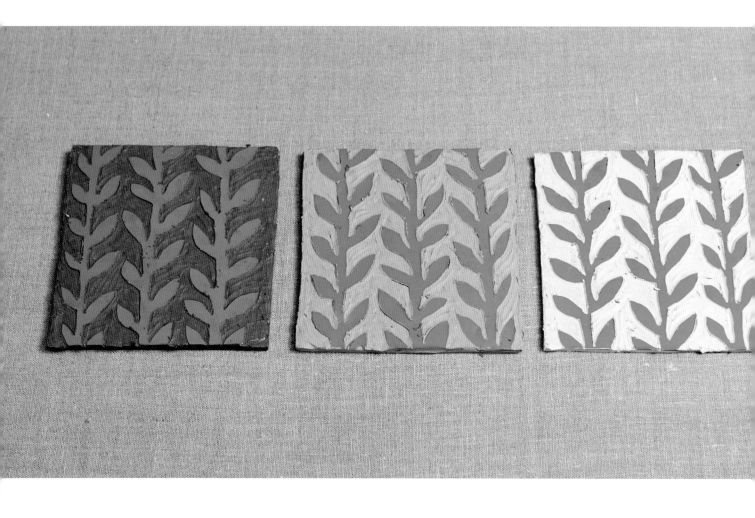

# CHOOSING CLAY

There are many clay bodies to choose from to make your work. Although many of the techniques in this book can be applied to just about any clay body, I recommend you use one of three kinds of clay for practicing these techniques. The projects in this book use a mid-range porcelain that I have in my studio. Porcelain has many beneficial characteristics when used for surface decoration. Its white color allows for vibrancy of color and a contrast when adding line drawing. For me, using porcelain as a drawing surface is not too far off from drawing on a blank piece of white paper. For the surface techniques in this book, use a clay body that is already familiar to you, as you will have access to the correct glazes for your clay body and a better sense of its limitations.

### » Porcelain

Porcelain is wonderful clay to use for surface decoration. Colors pop off the white clay! It is non-groggy, which means it is smooth and there is no sand in it. So when using a sponge to wipe the surface, there is no sand or grog that comes up. When scraping the surface of porcelain, there are no drag lines from sand or grog. Porcelain also takes rehydration well when it is still green/unfired, so sponging is welcome and spraying with a water bottle is okay. I have had great luck keeping porcelain pots at the leather-hard state in a damp box for months! If you are relatively new to throwing or handbuilding, working with porcelain can be a challenge. Porcelain's fine particles make cracking, slumping, and warping more likely in both handbuilt and wheel-thrown ceramics. Do give porcelain a try and don't be discouraged if you find it hard to work with! It is well worth practicing with porcelain, because the benefits outweigh the challenges when it comes to providing a great ceramic surface for the techniques in this book. Porcelain is available in mid/high range firing temperatures.

### » Stoneware

Stoneware is a good clay body for the studio potter and sculptor. It is typically fired to a high temperature and often has some grog in it. The color of stoneware can range widely from very dark to an off-white due to the impurities in the clay, which affect the brightness of colors added to its surface. Stoneware will work well with many of the techniques in this book, but not as well with techniques that require sponging, such as mishima (page 57) and shellac resist (page 103). Sponging will bring up the sandy texture of grog in stoneware. You should be able to find stoneware clays that do not have grog in them; typically, throwing clays have little to no grog.

### » Earthenware

With a high percentage of iron and other impurities, earthenware hardens at a lower temperature than stoneware and porcelain. Typically, earthenware is red to white in color and available with or without grog. Similar to stoneware, earthenware will work well with the techniques in this book if it doesn't contain grog. Because most earthenware clays are red, white, and light colored, slips and underglazes will contrast well with the clay. Colors in ceramics are brightest when fired at lower temperatures, so working with earthenware can be great for a larger range of color and brighter color palettes.

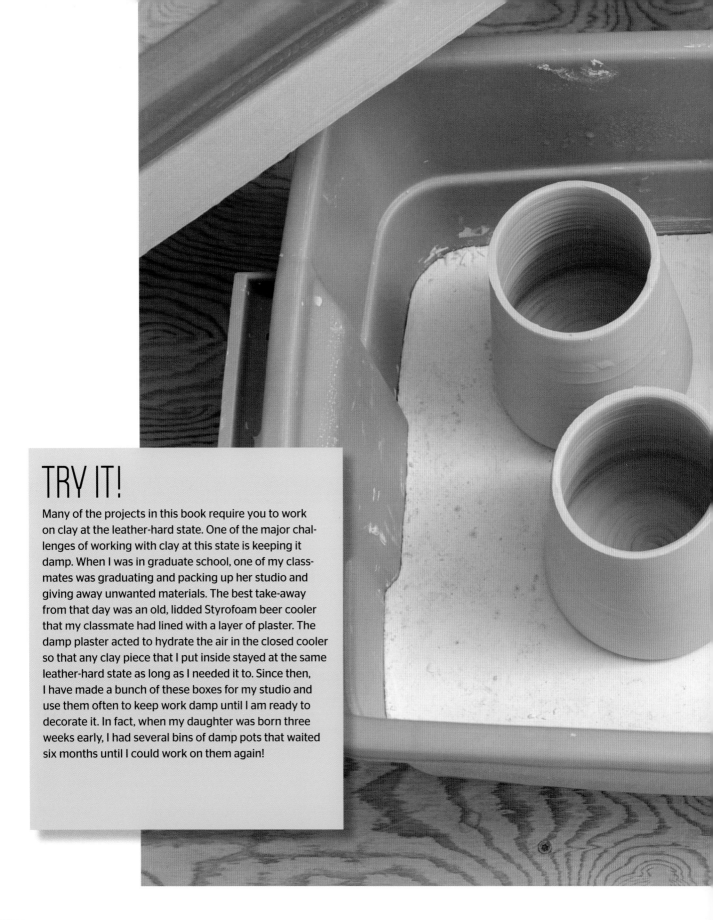

# TRY IT!

Many of the projects in this book require you to work on clay at the leather-hard state. One of the major challenges of working with clay at this state is keeping it damp. When I was in graduate school, one of my classmates was graduating and packing up her studio and giving away unwanted materials. The best take-away from that day was an old, lidded Styrofoam beer cooler that my classmate had lined with a layer of plaster. The damp plaster acted to hydrate the air in the closed cooler so that any clay piece that I put inside stayed at the same leather-hard state as long as I needed it to. Since then, I have made a bunch of these boxes for my studio and use them often to keep work damp until I am ready to decorate it. In fact, when my daughter was born three weeks early, I had several bins of damp pots that waited six months until I could work on them again!

# MAKE YOUR OWN DAMP BOX

## Tools

water

quart (946 ml) measuring cup

bucket for mixing plaster

digital kitchen scale

No. 1 Pottery Plaster

sifter

lidded Styrofoam cooler or plastic storage bin with a clamp-down lid

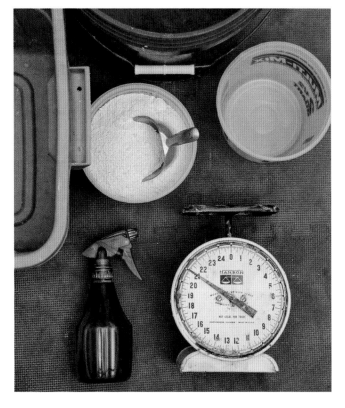

**1.** Calculate how much plaster to mix to cover the base of your container. To calculate the volume of a rectangular shape, multiply the length by the width by the height. For a rectangular container damp box, you only need 1" to 2" (2.5 to 5 cm) of plaster in the base of the container.

**For example, to make enough plaster to cover 1" (2.5 cm) of the base of a rectangular damp box that measures 12" (30.5 cm) long by 10" (25.5 cm) wide, calculate as follows:**

12" x 10" x 1" = 120 cubic inches (30.5 x 25.5 x 2.5 cm = 1944 cubic cm)

You will need 120 cubic inches of plaster to fill 1" (2.5 cm) of the base of this container.

Divide the volume by 80 to find the number of quarts of water you will need to make the right amount of plaster.

120 cubic inches divided by 80 = 1.5 quarts (1944 cubic cm divided by 80 = 24 L)

You will need 1.5 quarts (24 L) of water.

**To figure out the weight of the plaster you will need, multiply the number of quarts of water by 3.**
1.5 quarts x 3 = 4.5 pounds (24 L x 3 = 2 kg)
You will need 4.5 pounds (2 kg) of plaster.

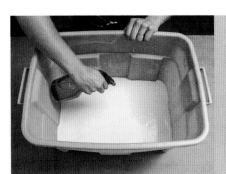

# TIP
Keep the plaster damp by adding small amounts of water directly to it when the damp box begins to dry out. Keeping the plaster damp is what makes the box damp. If the plaster is too wet, however, your pieces will become oversaturated and this will likely cause the clay to crack and slump. Plaster that is damp to the touch and not visibly wet is best.

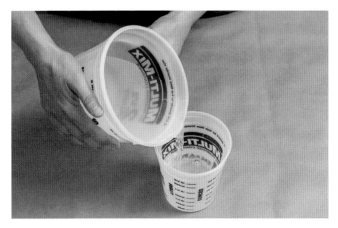

**2.** To mix the plaster, first measure out the amount of room temperature water, about 70°F (21.1°C), into a bucket.

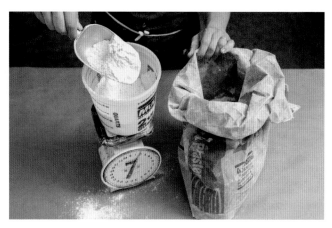

**3.** Use a scale to weigh the correct amount of plaster.

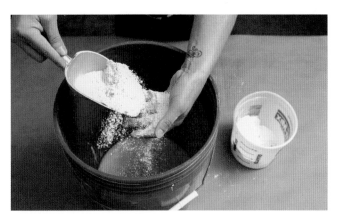

**4.** Gently sift the plaster into the water, adding it gradually until all the plaster is in the water.

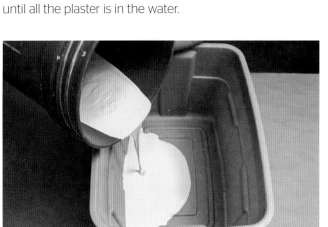

**5.** Using your hand, stir the plaster and water, mixing them together gently. Try not to add air bubbles to the plaster. Bounce the bucket up and down a bit to jostle the air bubbles to the surface.

**6.** Once the plaster is mixed and beginning to thicken to a yogurtlike consistency, pour it into the bottom of your box.

**7.** The plaster should set fairly fast. In 15 minutes or so, it should feel hard to the touch. It will still be wet, which is fine. Your damp box is complete! If the plaster is still soft to the touch and not set after 15 to 30 minutes, the plaster may be too old. Remove it from the container, buy fresh plaster, and repeat the process from the start.

# SLIP, UNDERGLAZE, AND GLAZE

There are many different ways to add color to ceramics. For the projects in this book, I recommend sticking to slip, underglaze, and glaze. Always test new materials before using them in the studio. Also, limit yourself to one or two colors so you can learn the process without a large investment in time and resources.

## » Slip

Slip is a liquid clay that can be applied to the ceramic surface before firing, usually at the leather-hard state. Slip can be colored using ceramic stains and oxides. It is important to test your slip before using to make sure that it fits your clay body. Applying slip to stoneware and earthenware surfaces is a great way to achieve a bright white before layering on brighter colors. Slip cannot be applied after bisque. Because slip is mostly made of clay, it is a static material, so it won't move or melt in the firing process. This is great if you want to have consistent results in the kiln— no surprises! This is also useful for predicting how your end product will look. For those of you with access to a glaze lab, I have included a recipe on page 153 for a versatile slip that works on low-fire to high-fire clays.

## » Underglaze

Underglazes are commercially manufactured and used to add color at both the green and bisque states. Underglaze can be used on bisque because it contains calcined materials that have already been fired and therefore have pre-shrunk and will not crack off the surface when applied to bisqueware. Like slip, underglaze is a very static material, so it won't move much during the firing process. If you fire commercial underglazes in mid-range kilns that are meant

to be fired to cone 05, at this higher firing temperature you are basically turning the underglaze into a matte glaze. This can cause certain colors to move more than others because they naturally flux a bit at a higher temperature. For this reason, I can use underglazes on the bottoms of

# TRY IT!

A great way to add a layer to your ceramic surface is by using tinted clear glazes, which allow you to add a layer of color over your underglaze or slip decoration. Keep in mind that if you try finishing your work with tinted glazes, the tint will affect the color of the underglaze or slip decoration underneath. As always, test glazes and underglazes together before using them on an important piece. Colors in ceramics don't react or mix together in the same way as paint. Adding white to red doesn't necessarily mean you will get pink! Because glazes move and melt together, decorating with glazes can bring unpredictable (and often exciting!) results. The Resources section on page 151 lists some great commercial tinted glazes for mid-range firing. And the Recipes section on page 153 lists percentages of stains and colorants for tinting clear glaze.

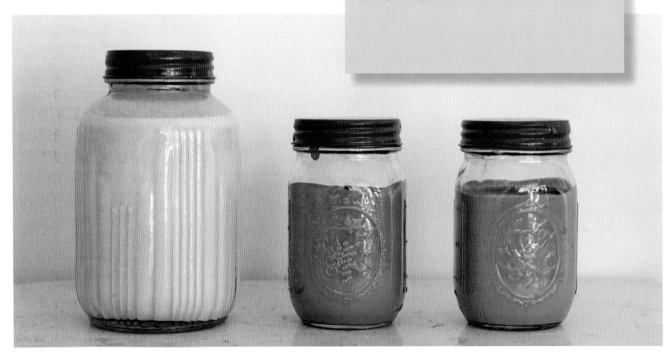

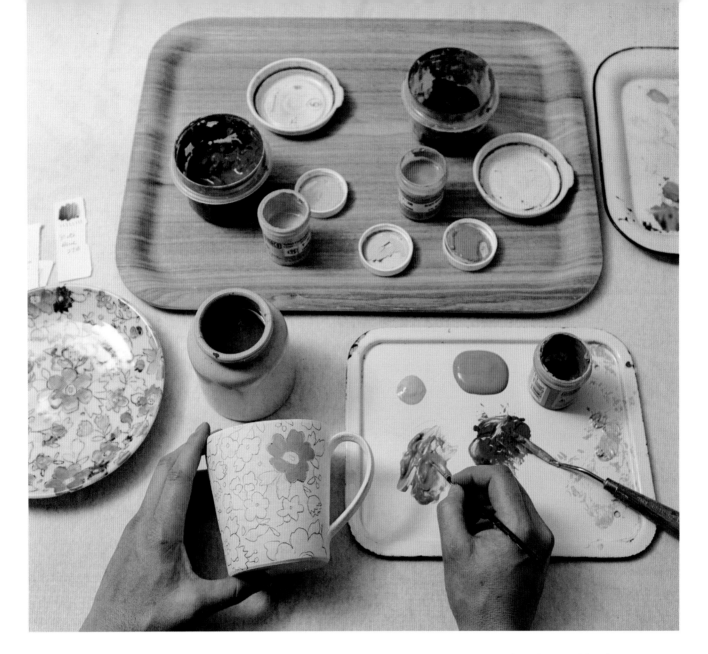

my work and they don't stick to the kiln shelf during firing. There is just enough melt in the underglaze so that it sticks permanently to my pot, not the shelf. Because of its versatility, underglaze is used in almost all of the projects photographed for this book.

## » Glaze

Glaze is a glassy vitreous mixture that fuses to ceramics through the firing process. Glaze acts to seal the surface of clay, making it waterproof and food-safe in addition to adding color and decoration. To streamline my studio practice, I use one clear glaze for all of my work and then add color using underglazes and slips. For almost all of the projects

in this book, I used a clear glaze designed for dipping, not brushing, that has been fired in oxidation and tested to fit the clay body I use. I recommend that you test any glaze you use to make sure it fits your clay body as well. See page 153 for the recipe I use for mixing the clear glaze and some suggestions for making translucent tinted glazes. If you have access to a glaze lab, you can mix your own glaze.

# FINDING INSPIRATION

One of the most challenging parts of the creative process can be finding the inspiration to begin. In this chapter, I'll provide ideas on how to find and listen to your muse. My work is typically grounded in history, and I usually draw inspiration from a found pattern or image. I use museum archives, libraries, books, and Internet resources to research and find inspiration to design and create. For any given project, I keep a running folder or inspiration board of printed imagery to use as a resource as I sketch and design.

My processes vary; sometimes I find a pattern that dictates the form I make. Other times, I may have bisque forms lying around that I haven't been inspired to glaze until just the right surface design comes along. Through self-awareness and observation of my own habits, I have come to recognize the feeling I get when I am inspired. Keeping a sketchbook with you at all times to write down an idea before it passes is a great way to observe those moments in yourself.

Desire often motivates me to create. It may be a covetous desire to have a special pattern or an object from history, or to learn how something was made. As artists, we have the ability to make physical the things we desire, which is both exciting and motivating.

I encourage you to practice the surface techniques with the templates provided so that you will gain confidence in the techniques in this book and have encouraging results. It is important to develop your own artistic ideas and interests, however. Once you have practiced the techniques, I hope that you will begin to make new surfaces through your own artistic exploration. This chapter aims to help you find inspiration and develop your own artwork for the ceramic surface.

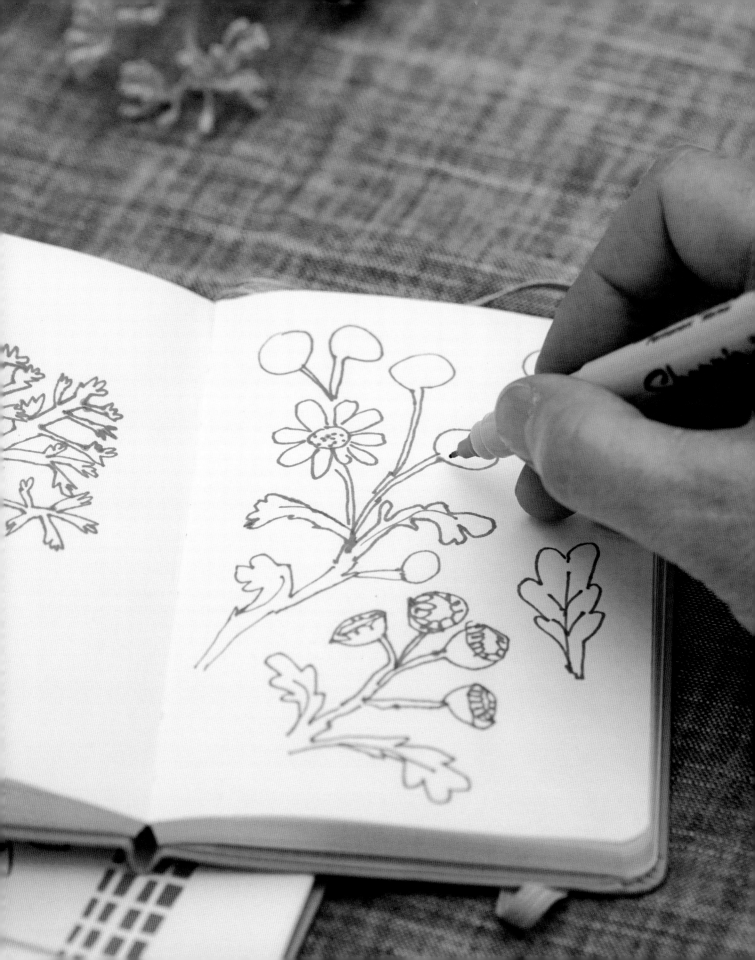

# SKETCHBOOK

Inspiration can come as an impulse—fleeting. Often I find that I come up with some of my best design ideas in the time between wakefulness and sleep. I keep a sketchbook by my bed so I can jot down the ideas as they come to me, ensuring I won't forget them come morning. It took a long time for me to recognize that this time of day—those last waking moments before I doze off to sleep—is my productive time for new ideas. By paying attention to the times when you drift off in thought about your work and keeping a sketchbook on hand to capture those thoughts, you will become more aware of when you are most inspired.

A sketchbook can be as simple as a hand-size spiral notepad to keep lists and jot down ideas quickly, or it can be a place to fully develop ideas and make drawings. Some artists even use sketchbooks to collage and scrapbook inspiration. Use sketchbooks to record ideas and notes about what you want to make and how you want to make it in any way you feel comfortable.

I have shared images from a few pages of my sketchbooks to show that the illustrations range from more developed drawings to rougher sketches that act as concept notes for later work. I use a sketchbook at different times for different reasons. Consider it a journal—something personal and only for your eyes. This will give you permission to record anything you like. I encourage you to keep past sketchbooks. There have been many times when I have returned to old sketchbooks and been inspired to make things based on ideas from long ago. You never know when those sketches will come in handy.

# TRY IT!

Even sketching can take practice! Try doodling, which warms up your hand, improves drawing skills, and allows your mind to wander with results on the page. Relax and let your mind go while your hand responds. Try a free-association approach, using either images or words. If you want to doodle as a way to develop specific ideas, try writing out words that are associated with your idea, cutting them out individually, and placing them into a bowl. Then pull out one at a time and respond with doodles on the page. Doodle for as long as you are inspired by the word. Pick another word when you are ready. This type of free association can be a great source for developing inspiring ideas. Creative writers use this technique all the time—why not ceramic artists, too? See page 146 for some doodle prompts to try.

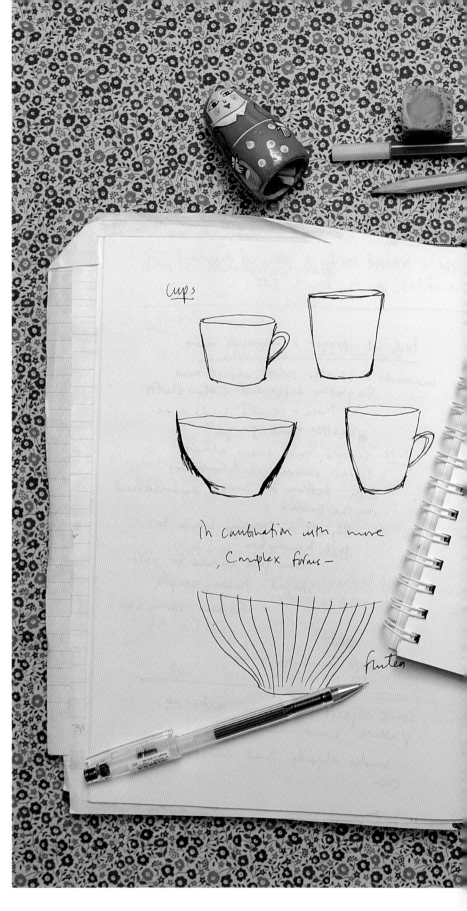

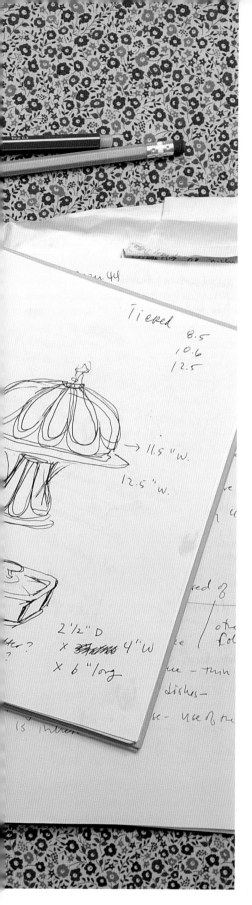

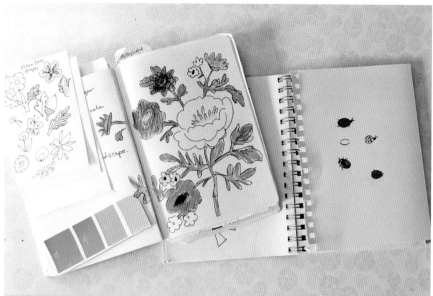

# TRY IT!

Look through old books and magazines and cut out or photocopy images that inspire you. Maybe you see color combinations you want to use in your own work, or a shape for a piece that you'd like to make. Maybe you find a historic pattern or graphic image that would be fun to try on the surface of a piece. Scrapbook and collage these inspirational images into your sketchbook to use as references and source materials. Make notes on the images, or try using them as the basis for a sketch. Feel free to doodle right on the source imagery! Track what is on-trend and current in the world, such as popular contemporary decorating colors.

# ARTIST INSPIRATION

**Rae Dunn**

a delicious ice cream bar

BIRTHDAY

the stick.

ÉTUDE DE POIRE.

THIS WAS A PERFECT PEAR THAT
I PAINTED QUICKLY SO I COULD EAT.

7 JUNE 2014

HERMITAGE SAINT PONS

2013

SÉLECTION

CÔTES
DE PROVENCE
APPELLATION D'ORIGINE
PROTÉGÉE

MIS EN BOUTEILLE AU
CHÂTEAU BASQUE
SCEA DU CHÂTEAU
PROPRIÉTAIRE-RÉCOLTANT
FIGANIÈRES-VAR-FRANCE

PRODUIT DE FRANCE

75cl - 13% vol.

WENT TO GOLFE-JUAN WITH PASCAL,
PRICILLA, and ALE FOR THIS BOTTLE
OF ROSÉ and THESE H'ORDEUVRES ——→
a.d I DROVE THE CAR HOME!

orange
brown
tapenade.

pink
jambon.

caviar
chèvre.

yellow
thon.

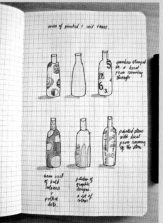

Rae Dunn is a ceramic artist and designer with a love of text and image. Rae is an avid blogger and has developed a large social media following. One of my favorite things to see on Rae's blog each week is her sketchbook page. Rae paints and draws what she sees on her field trips away from the studio, bringing back a rich and exciting source for her ceramic surfaces. Rae was happy to share her sketchbook here as an example of one of many ways you can use your sketchbook to find inspiration. To find out more about Rae's ceramics, see page 74.

# INSPIRATION EVERYWHERE

Finding inspiration can be as easy as taking a closer look at the world around you. Our own homes and daily lives can also inspire. Family and pets can become muses. Fabric patterns on your favorite quilts and clothing become designs to draw and reinterpret. Wallpaper and old china patterns can become new surfaces for your artwork. I have even gone to my closet for inspiration! Often new surface textures come from the oddest places—the bottom of your shoes, a floor mat from your car, the texture of packaging from a farmers' market trip, and so on. Keep your eyes and mind open because you never know where your next tool, texture, or color palette will come from.

Many of us carry smart phones these days. Smart phones can help you keep a visual record of inspiration through photographs and applications. Try going for a walk and gathering inspiration from the neighborhood and nature around you. Gather branches, leaves, and wildflowers to draw or press into your surfaces. Photograph the colors you see in nature and your environment. Capture the architecture of the buildings you pass along the way.

Always have your sketchbook with you while you observe the world around you. In addition to taking photos, try sketching or doodling. Sketching takes practice, but it is a great way to record what you see. I often find myself sticking leaves into my sketchbook or pressing little flowers between pages. I will even keep candy wrappers or other packaging and tape them into my sketchbook when there is a good border pattern or color palette used.

*A montage of the author's Instagram photos.*

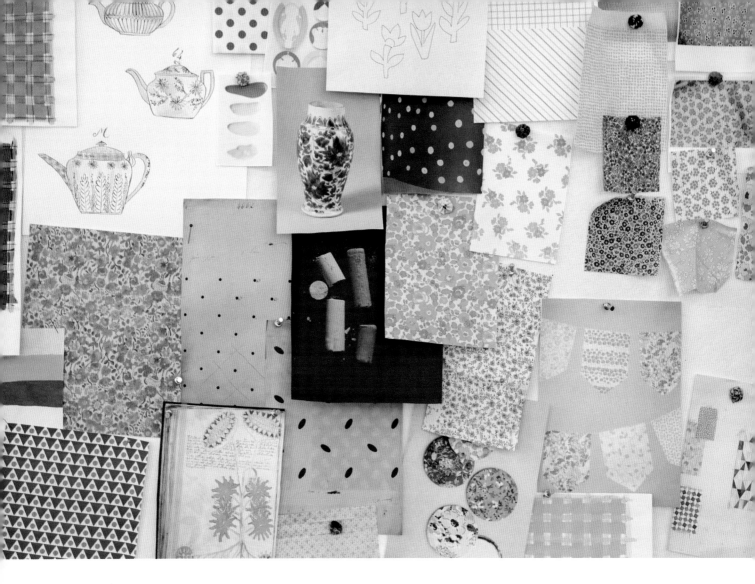

# INSPIRATION BOARDS

Inspiration boards can be a fun visual way to gather information to inspire a larger project or group of related artwork. I use inspiration boards most when I am developing a large collection of artwork because I need to create multiple objects that are different, yet relate well to each other. I will add images that work and remove others that don't, editing what I have until I have gathered enough information to inspire the collection. I look for sources for shapes of forms, color inspiration, and variations on a theme. When I am researching imagery for inspiration boards, I often end up with extra source material that inspires my next project.

Gather pages from your sketchbook, magazine clippings, your own photos, and found ephemera to assemble an inspiration wall. Use colorful or patterned washi tape and tacks to pin things to the wall—even objects can become a part of the board. Find new color combinations in the paint chips at the local hardware store and include those on the wall. Add inspiring quotations and sayings that describe the mood of the artwork. Have fun! Trust your intuition and taste; you will know whether something works on the board or needs to be removed. If you are stumped, ask a friend with a good eye to take a look.

# TRY IT!

Pinterest is a great online inspiration board tool. I find that when I am gathering inspiring imagery online to make a new collection, I clutter up my computer desktop with lots of images I have clipped from websites. Pinterest is a great way to keep all of the inspiration you find online in one place, organized into categorized files that can be for specific projects. Some of my boards on Pinterest are ongoing and more general, and I have some boards that I keep set as private so I can generate ideas that other people won't see. One thing that I love about Pinterest is that the original source for the image is usually easy to find. It is simple to open an account; visit www.pinterest.com to start pinning!

# TRY IT!

Keep a collection of fun surface textures that you find out in the world. When you are at yard sales and flea markets, look out for old doilies, crocheted work, embroidery, and scrap pieces of lace. Old baskets and fabrics, textured wallpaper, and place mats are all fantastic textures to source for your work.

When you are out on a walk in the woods or on the street, keep an eye out for textures in nature: old bark, a cool stone, flowers, or sticks. Look at discarded items on the street—become a Dumpster diver! Store all your finds in your toolbox to reference later when making textures on the surface of your work.

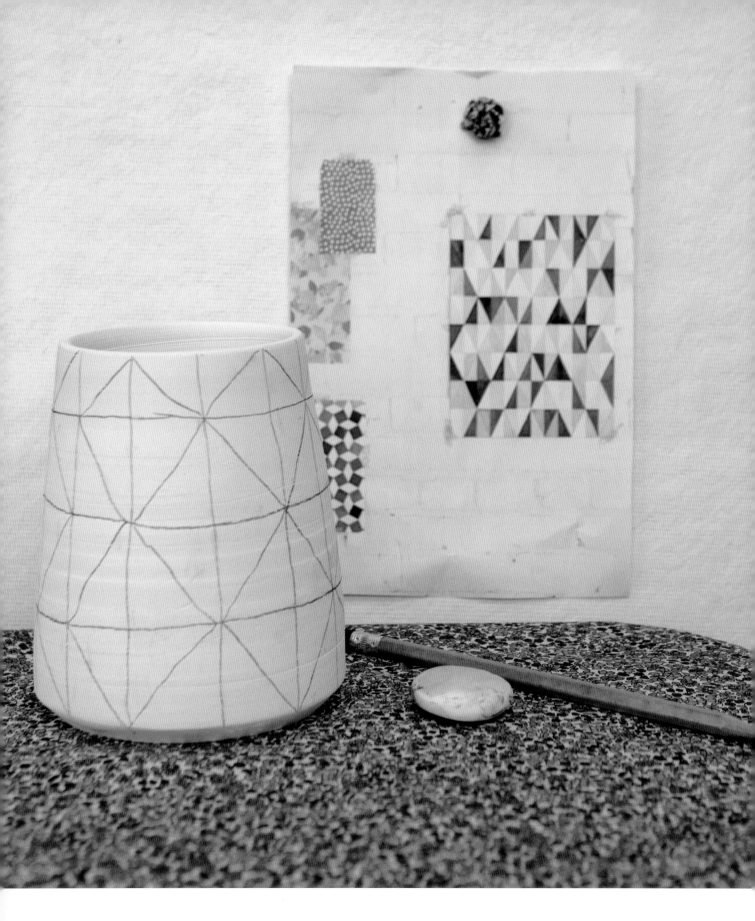

# 3

# COMPOSITION AND FORM

||||||||||||||||||||||||||||||||||||||||||||||||||||||||||||||||||||||||||||||||||||||||

Marrying form and surface is one of the biggest challenges in ceramics. Applying surface to ceramics is a balancing act that takes practice. But with a few tips on how to approach composition in relationship to form, and formulas for how to add surface decoration to your ceramics in your back pocket, you'll begin to get the hang of it. Taking cues from the form of your work as well as the function can go a long way toward a successful marriage of surface and form. On the following pages, I'll provide basic instruction on how to create your own repeating patterns as well as ideas for how to use color and develop your own color palettes.

# MAKING FORMS THAT WORK

When you start to make complex surfaces, it's best to stick with a simple form. When I designed forms for heavily patterned surfaces, I generally aim to make as simple a form as possible so that the focus of the work is on the surface. Keep in mind that whatever form you make becomes the frame for the surface. Tiles and plates easily read as more two-dimensional because they are already flat. A plate conveniently comes with a built-in frame in the rim, making it akin to painting on a canvas. You can even hang a plate on the wall!

Take cues for how to decorate the complex surfaces from the changes in planes in the form itself. Color blocking and blocked patterns can be straightforward ways to deal with a complex form. This is where planning ahead and reviewing your sketchbook can benefit your artwork. Drawing the outline of the form on paper and playing with colored areas will give you a sense of what will and what won't work before you commit to finishing your surface.

As with much of ceramics, make multiples and test patterns on your forms as a part of your design process. In general, make multiples of the same form on which to test a new surface design before committing to a final piece. Even once you have settled on a surface composition, adding color can change how you perceive the surface, so having extras on which to test color palettes will lead to better results.

# TRY IT!

With technology expanding constantly, many of us have access to opaque and overhead projectors (both digital and ana-log). The ability to feed transfer paper through ink-jet printers makes it possible to use almost any image with an overhead projector. If you have access to a projector, use it to play with enlarging your sketches or printouts and projecting pattern ideas and colors onto the surfaces of your work before you begin. This technique gives you an enormous amount of infor-mation about the scale and density of the patterns or imagery you are interested in incorporating onto your work. It can inform color choices and even give you thoughts on how to adjust the form. I often make templates for tracing using this technique. Once you have the right scale and sense of composition, trace the pattern onto a piece of paper placed in front of the projector. This tracing can then be used as a transfer. (See page 53 to learn how to make your transfer.)

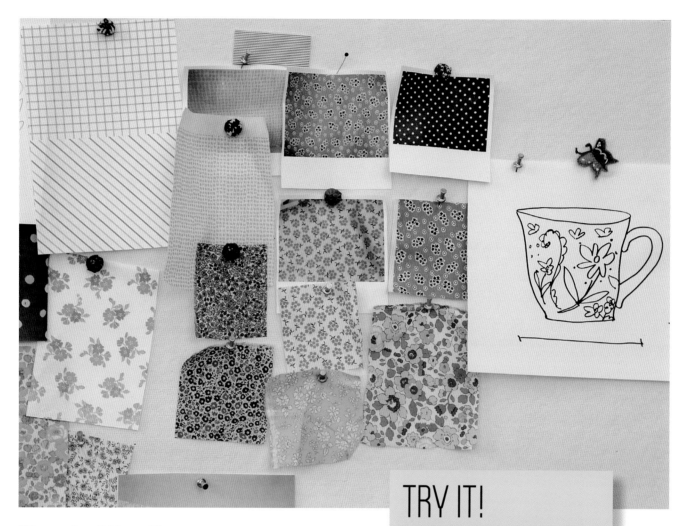

## "Dressing" Your Form

One simple way to approach designing for the surface of your three-dimensional ceramic work is to think about how you "dress" yourself and then consider "dressing" your form. Because we dress ourselves every day, we understand how to put together an outfit—how to match our clothes. We know which patterns go well with others, which colors match, which clash, and so on. In talking about pottery, the words we use to describe form are directly related to the words we use to describe the body. For example, a mug can be described as having a "lip," and a ceramic form may have a "waist" and a "foot." Thinking of the three-dimensional form in relationship to the human figure can inform how we decorate the ceramic surface.

## TRY IT!

For a week, take photos of the outfits that you put together and wear. Try using these combinations on the surfaces of your work. Work with everything from the colors of the clothes to the patterns—play with stitch patterns, ruffles, and darting. This could even become a source of inspiration for how you make the actual forms you'll be decorating. Are the clothes you wear more textural and dimensional? Architectural? Do you wear a lot of pattern or color? Try working your clothing style into your ceramics.

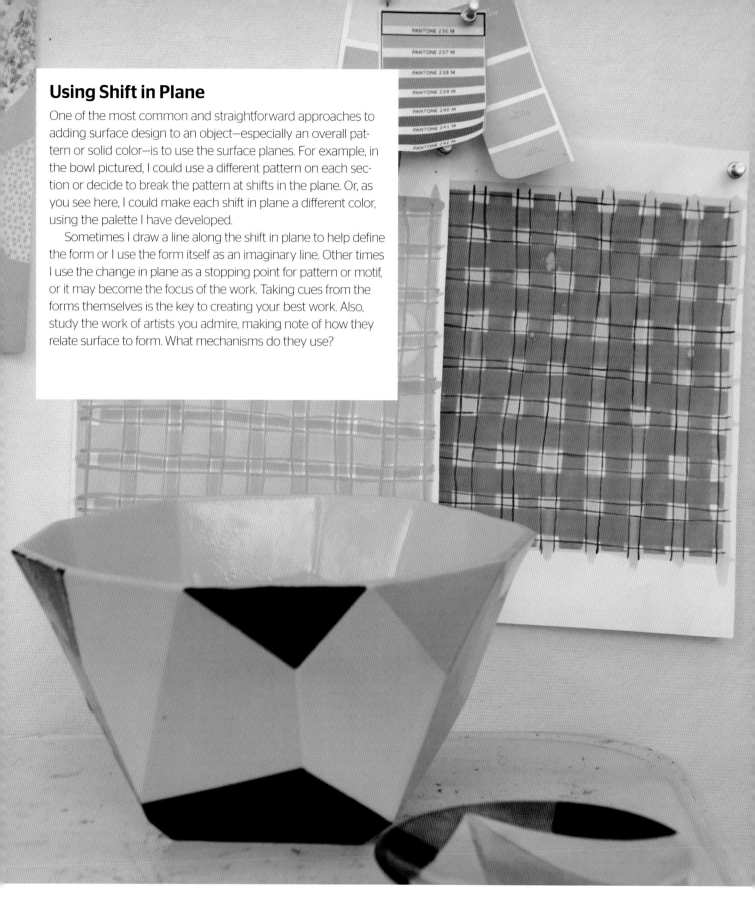

## Using Shift in Plane

One of the most common and straightforward approaches to adding surface design to an object—especially an overall pattern or solid color—is to use the surface planes. For example, in the bowl pictured, I could use a different pattern on each section or decide to break the pattern at shifts in the plane. Or, as you see here, I could make each shift in plane a different color, using the palette I have developed.

Sometimes I draw a line along the shift in plane to help define the form or I use the form itself as an imaginary line. Other times I use the change in plane as a stopping point for pattern or motif, or it may become the focus of the work. Taking cues from the forms themselves is the key to creating your best work. Also, study the work of artists you admire, making note of how they relate surface to form. What mechanisms do they use?

## Overall Pattern vs. Motif

Cylinder forms and multifaceted forms, such as mugs or tumblers, can be more challenging to decorate than the single plane of a plate because there is no obvious start or finish to the surface and you must consider both the inside and outside of the form. When working on a three-dimensional shape such as a cylinder, there are endless ways to break up the form. Consider each of the following approaches:

### A. MOTIF
Using a single motif, as shown here, creates a focal point without decorating the entire surface. Consider using motifs to begin to build a narrative by delineating two sides of the form.

### B. SECTIONED
Taking a cue from the form, I will decorate just the rim or base of a piece with an image or a repeat. This is similar to using the shifts in plane to direct where you apply surface decoration, but you can also section a straight-sided object and almost create an illusion of a change in plane through the use of pattern and color on the surface.

### C. OVERALL
A pattern that covers the entire surface can be striking and encourages the viewer to interact with the whole object. The trick is figuring out how to make the pattern fit correctly onto the form.

# COMPOSITION

Everyone struggles with composition. There is no perfect formula for composing a great piece, but I have developed some reliable tips to help with this important piece of the equation. With practice, you will begin to develop your own mechanisms for composing the surfaces of your work.

**1.** Start the decoration on the surface of your ceramics with the focal point of the pattern or image. For example, it could be the largest flower in a repeat pattern, or the largest part of the image. If you are using a visually balanced pattern, begin adding the decoration in the area where you'd like the focus to be. The focal point does not necessarily need to be in the center of your work. In fact, it is often best to set it off-center unless you would like the form to be symmetrical or uniform. Starting from the focal point and working your way out can be a good way to complete the surface, because this approach allows you to make sure that you place the focal point of the piece in the right spot.

**2.** In general, it is more visually pleasing to break up patterns and forms into odd numbers—one, three, five, and so on. When using sections and motifs, consider dividing the form into odd-numbered sections. You can do this by evenly measuring out the form from the top or bottom and marking it with a pencil.

**3.** Varying the scale of imagery in a composition and mixing up the amount of space between imagery in a pattern creates movement and points of interest. Varied thicknesses and line qualities also add interest.

**4.** Use color to move your eye through a composition. Color can emphasize the focal point in a composition if very little color is used elsewhere or by using complementary colors. Don't forget that the clay has its own color!

**5.** In clay, we have the ability to add textures to the surface of our work, which is a quality unique to the medium of ceramics. You can place texture on your work in the same way you compose color or line. Textured areas can emphasize the focal point in the surface.

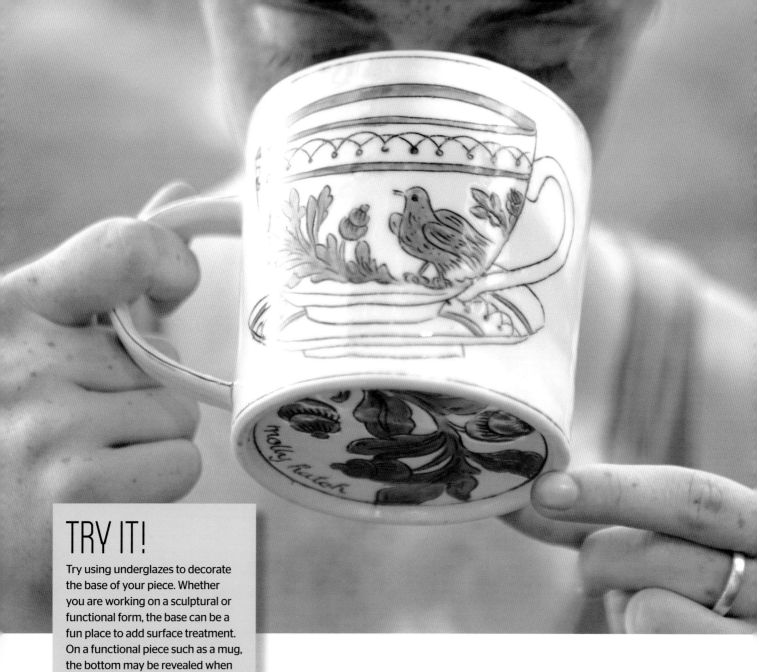

# TRY IT!

Try using underglazes to decorate the base of your piece. Whether you are working on a sculptural or functional form, the base can be a fun place to add surface treatment. On a functional piece such as a mug, the bottom may be revealed when you are taking the last sip of coffee, giving the person sitting across from you a flash of an image. In sculpture, the base can be a hidden gem under your piece that only the collector knows about. Underglazes generally won't stick to a kiln shelf when unglazed, but they will stick to your clay. Experiment!

## Inside and Base

Don't forget that a three-dimensional form has a base and an interior space that should be taken into consideration as a surface for decorating. When making things by hand, we have the ability to add detail in unexpected places. Try decorating the base of your work to add interest—especially on functional pieces that are seen upside down in a dish rack or hanging from a cup hook. Sometimes adding a single color liner glaze to the interior of a form or a simple border can help the piece feel more finished.

# Designing Your Own Repeat

Although there are many sources out there for existing surface patterns, it is always fun to create your own by hand, especially if you plan to sell your work. I use hand-drawn methods all the time for making repeats for my surfaces and other products. It is a great way to come up with new imagery. The following pages show two well-known methods for creating a repeat pattern by hand.

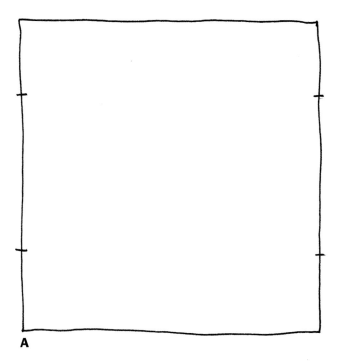

**A**

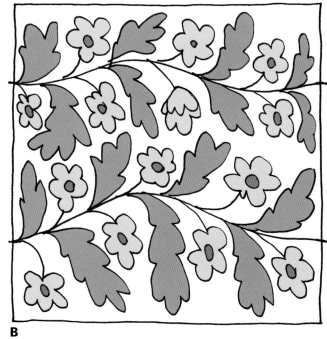

**B**

**C**

## BLOCK REPEAT

**1.** To create a block repeat, draw marks on both ends of one square at the same measured points (A).

**2.** Then draw an image that fits in between the marks, beginning and ending at the marks (B).

**3.** Repeat the square to create the overall repeat pattern (C).

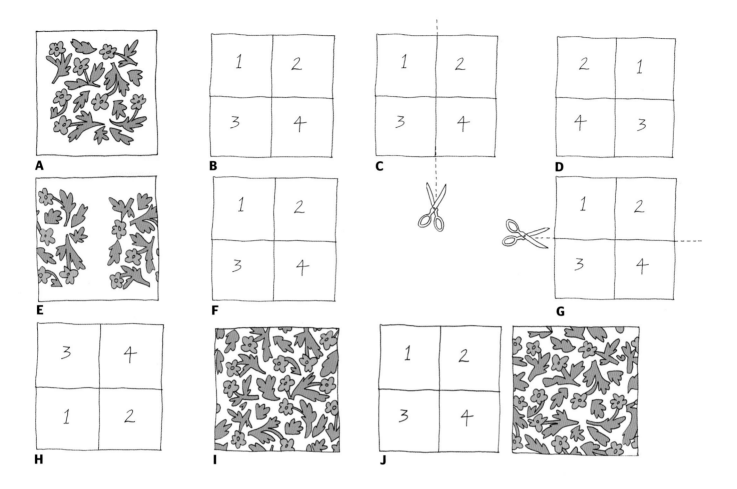

## PAPER-CUT REPEAT

**1.** On a blank piece of paper, draw your design in the middle of the paper, staying away from the edges (A).

**2.** Turn your piece of paper over and draw two lines, dividing the paper evenly into four parts, numbering the parts 1 through 4, as shown (B).

**3.** Cut your drawing in half vertically and tape it back together so the numbers are in the order as shown (C, D).

**4.** Turn back over to the design side. In the blank center, fill in the drawing, staying away from the top and bottom edges (E).

**5.** Cut the tape and tape the drawing back together as shown—back to its original numbering (F).

**6a, b.** Cut the paper in half horizontally and tape the paper back together so the numbers are in order, as shown (G, H).

**7.** Flip the paper back over to the design side and complete the drawing where it is blank, keeping away from the left and right edges of the paper (I).

**8.** Undo the tape, reconfigure the numbers to their original order, and tape in place. Your pattern now repeats (J).

# CONSIDERING COLOR

Learning how to use color will help bring your compositions and designs to the next level. Using your sketchbook to jot down color palettes and combinations can be very helpful as you design. Your sketchbook can become a great resource for recording color combinations that you like from magazines to hardware store paint chips and beyond. Snapping a photo of a color grouping that you like can also be a convenient way to take notes.

When researching color palettes that I like, I most often refer back to the folder of color combinations that I keep on my Pinterest page. Whenever I am using Pinterest, I inevitably find a color combination in an unexpected place, and I pin the image for later reference. It is rare that I have a specific color palette in mind when I am designing a new piece. More often, I am looking for the perfect color combinations to go with the pattern or surface I am already developing. I certainly have color palettes that I love and fall back on regularly, but I am always looking for new palettes to keep my work looking up-to-date and fresh. Whenever I am stuck on which colors I want to use together, I refer back to my Pinterest folder and find inspiration every time.

## TRY IT!

A color wheel is a great resource to have on hand as you explore new color combinations, and it's so easy to make your own. Making a color wheel can help you experiment with new colors and look beyond your color comfort zone. Play and see what is pleasing to your eye. Try combining colors that you like, and see what you can come up with that is new and exciting!

Using colored pencils to fill in sketches of your forms in your sketchbook can help you understand how color will affect your forms. Use the simple color wheel here or develop a more complex color wheel of your own to start exploring.

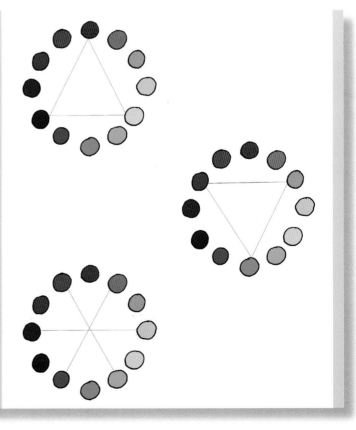

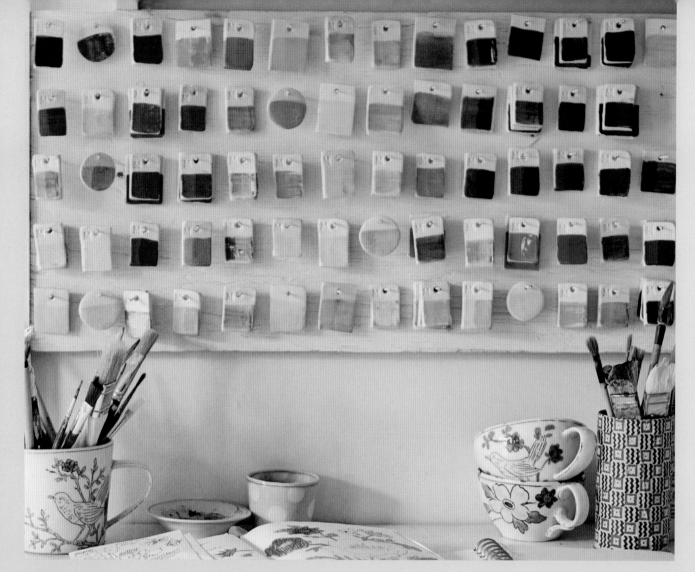

# TRY IT!

Make test tiles of all the underglaze, slip, and glaze colors you have in your studio so you have a master palette to choose from. When making your test tiles, consider applying one coat of underglaze or slip to one part of the tile and multiple layers to another part so you can see the variation in color when the glaze is applied in thin or thick layers.

The colors available to ceramic artists have come a long way, but the palette is not infinite. I often find color palettes I love, but cannot find a matching ceramic color, and I have to get creative about making a new color. Having the test tiles will give you a better sense of the finished colors available.

Also, there is a wonderful Pantone app for smart phones called "My Pantone" that I use all the time with the camera feature on my phone. The app allows you to find the specific Pantone colors in a particular image as well as identify the palette within an image. This comes in handy when I'm using an image as a reference for applying color to my work. I simply select a photo from my camera roll and plug it into the app to determine the colors in the photo.

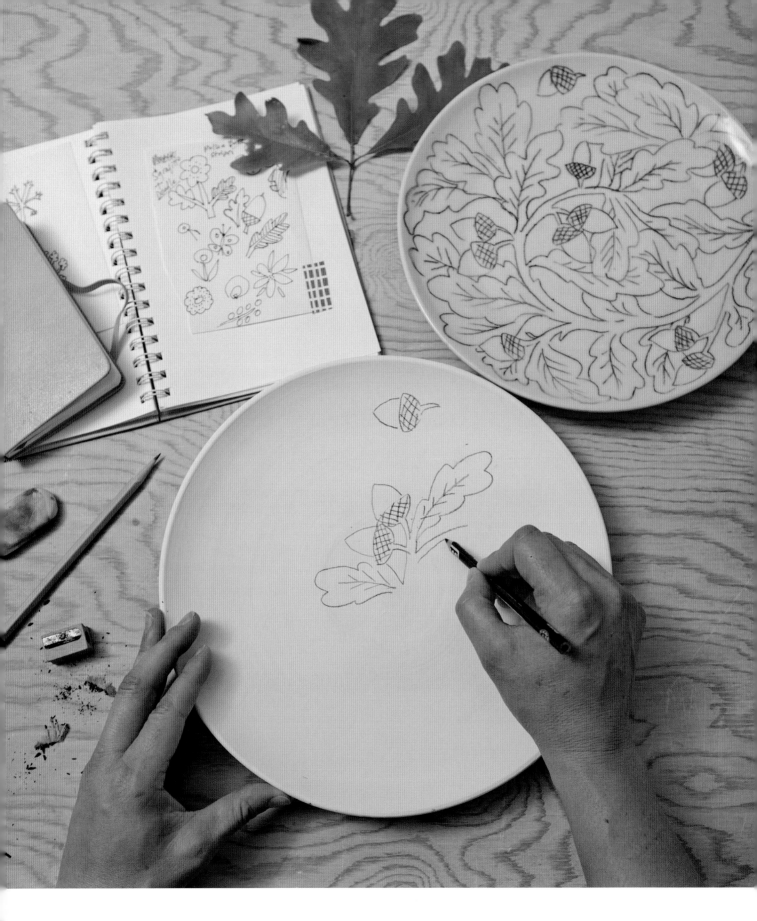

# MAKING LINES

Using line is my favorite way to create pattern on the ceramic surface. The projects in this chapter include multiple techniques for creating line-based artwork. Line drawing is perhaps the method we are all most comfortable with simply because we use line in writing. Line work is one of the most basic and effective drawing methods to use in designing surfaces for clay. I use the mishima technique to decorate almost everything I design in clay and other materials. The lines I draw

with mishima can be left monochromatic or colored in like a coloring book after the work has been bisque fired. The mishima line acts as a controlled ground for adding more expressive color using underglazes and glazes.

When I was in graduate school, I developed my own "transfer" technique for duplicating imagery onto the ceramic surface, and I share it with you in this chapter. Using transfer templates makes it possible to easily repeat a higher level of detail in your work. It also helps

remove some of the anxiety around drawing on clay because it takes that piece out of the equation. If you are worried about knowing how to draw and not sure where to start, try using transfers to add line drawings to your surfaces. This will give you the opportunity to work out some of your compositions on paper before you commit to adding them to clay. Use the projects in this chapter as a step toward learning to draw as well as learning to draw on the ceramic form.

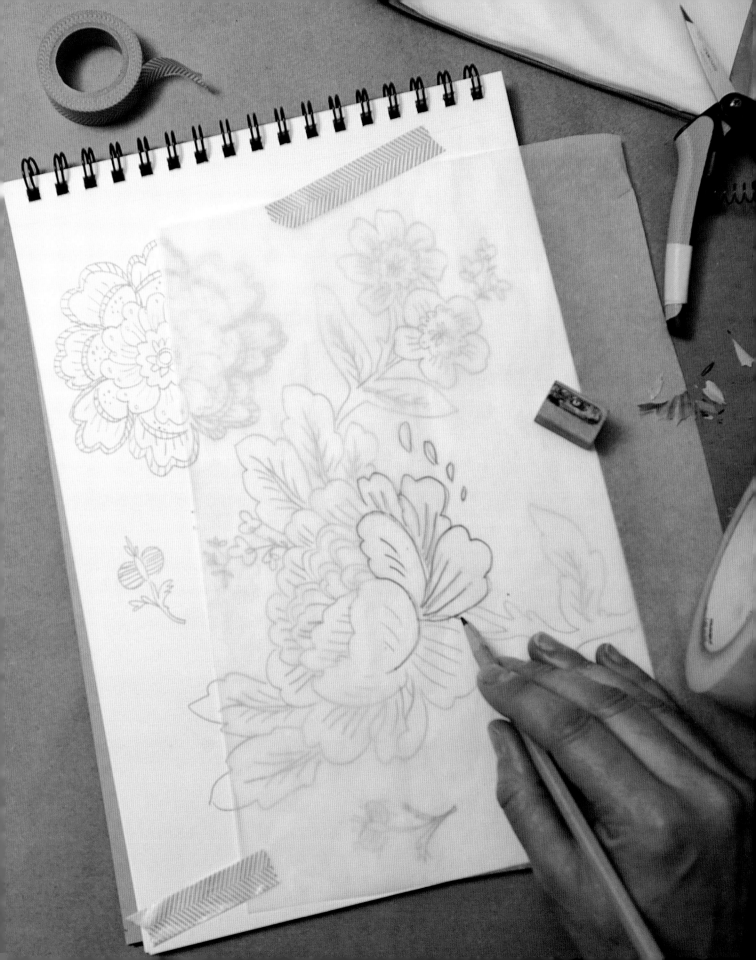

# MAKING A TRANSFER TEMPLATE

As a primer for many of the projects in chapters 4 and 5, this is a step-by-step guide to making the templates you'll need to transfer imagery onto your ceramic surfaces. These "transfers" are the result of a process I developed in graduate school when I wanted to draw large and complex surfaces on my ceramics, but was crunched for time. I later adopted this transfer method in the surface decoration of my functional pottery. These transfers allow you to repeat a design or motif on the surface of your work, removing much of the hard work of the design process for each piece you make. Using templates allowed me to make more highly decorated surfaces on my pottery and maximize my time. It also means that when a client comes to me needing to replace a broken piece, I have the same pattern on hand and can make a new version that matches the original. Although this process isn't archival, because old templates wear out or age, you can always trace over them to make fresh ones!

## Tools

- source template (see pages 143 through 149)
- tracing paper
- pencil or pen
- clear packing tape (thinner is best!)
- scissors

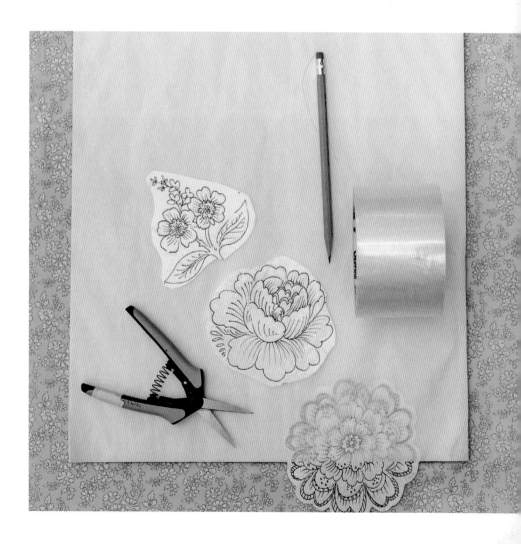

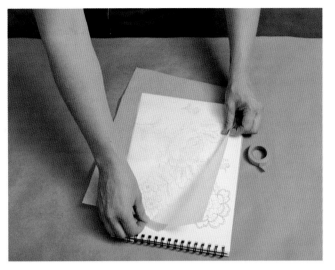

**1.** Chose an image to transfer onto your ceramic surface (using a template from this book, your own original, found imagery, or a photograph), and place a sheet of tracing paper over your source imagery.

**2.** Using a pencil or pen, trace over the lines from the image that you'd like to transfer onto the tracing paper. These will be the lines you will transfer onto your ceramic surface once your template is complete.

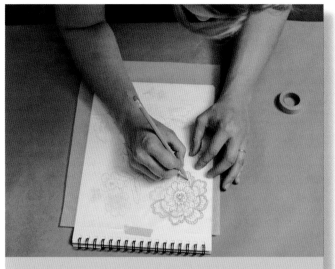

# TIP

I recommend tracing paper because it is transparent, which means you can reverse or mirror an image if you need to use the same image on the back of a form. And, because you can see through the tracing paper, it's easy to figure out where to place the image or register a design on your ceramic surface.

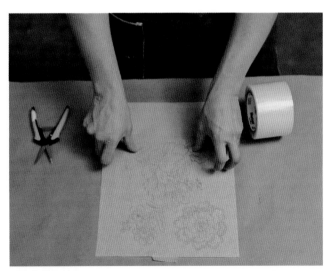

**3.** Once you complete the tracing, lay your traced image on a clean, flat surface.

# TROUBLESHOOTING

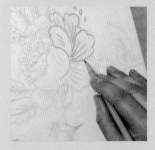

Sometimes tape can wrinkle as you laminate your tracing paper. This will be okay, but some of the wrinkles may transfer along with your image. If the tape is severely wrinkled, it may be worth retracing your image and starting again.

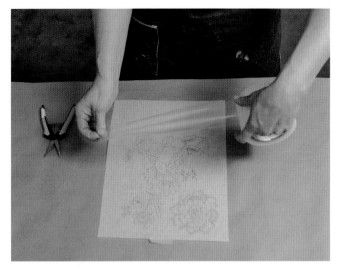

**4.** Carefully apply strips of lightweight packing tape to the front of your image to laminate it. Place the laminated side down and apply packing tape to the back as well.

# TIP

Using cheap, lightweight packing tape to laminate is an easy and inexpensive way to protect your transfers. Lamination that is too thick will make it challenging to complete the transfer and difficult to flex around a three-dimensional form.

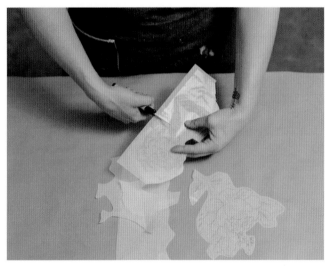

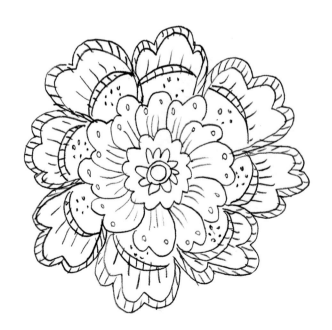

**5.** Cut around the image with scissors, leaving a small margin (about ¼" [6 mm]) around the outermost line you wish to transfer, removing the extra tracing paper as you cut. It is important to leave a small margin around the edge of your image; if you cut right up to the outer line in your artwork, that line will not transfer. Now you have a completed transfer for working on your projects!

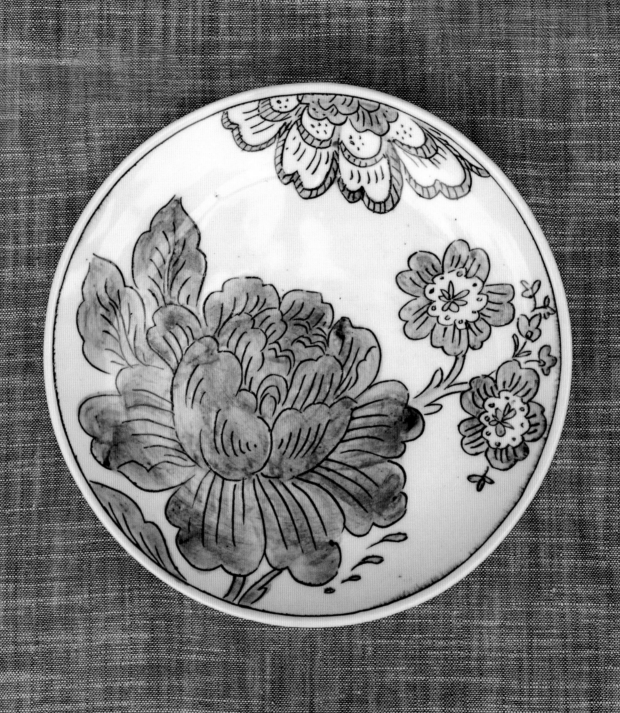

# MISHIMA SLIP INLAY

Mishima is the name for a slip inlay process that was adopted from Korea. The mishima line has a characteristic quality that appeals to the printmaker in me. It's a process very similar to engraving and the results have a similar aesthetic appeal—but it is in clay! I love the versatility of the mishima line. Although you can't make the line too thick or the underglaze will wipe out of the clay, you can make a line that varies from thin to thick and is calligraphic. This process lends itself to being colored after bisque, and it layers well with other techniques or even with additional mishima lines. I choose to draw the lines into the leather-hard clay with a calligraphy pen and a cartoonist's nib, but I have seen just about every kind of mark-making tool used for mishima. Experiment with new tools to find the one you like most.

## Tools

laminated tracing paper transfer (page 53) from template (page 143)

dry leather-hard ceramic surface

Amaco T-3 stylus

Hunt calligraphy pen and no. 107 nib

two 1" (2.5 cm) hake brushes, one for brushing clay crumbs from the drawing and one for applying underglaze

underglaze or slip

natural sponge

bucket of clean water

clear glaze

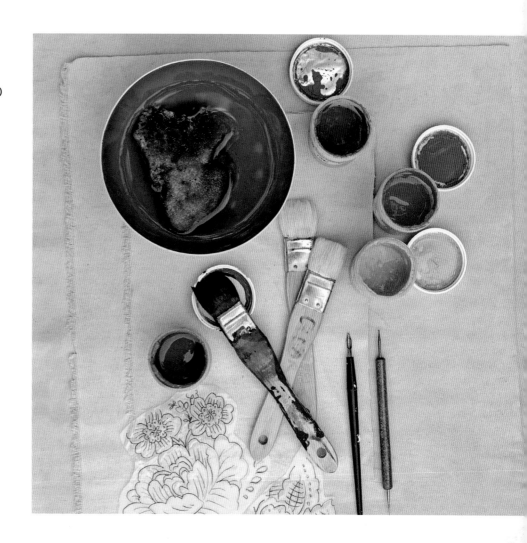

# Line Transfer

**1.** Using the laminated transfer from the book (see page 53 for how to make a transfer) or one of your own, hold the transfer template against the leather-hard ceramic surface and decide on the placement. Take advantage of the see-through template to create your composition. I often make minor adjustments at this point as I respond to the form to make the composition that works the best.

**2.** Once you have decided on the placement, hold the template in place and use your Amaco T-3 stylus to press down and trace over the lines you want to transfer to the surface of your piece.

## TIP

To see whether you missed a spot in transferring your image from the template to the ceramic surface, hold your transfer in place with one hand while gently lifting the other side of the template with your other hand to peek beneath to see your progress. When you are ready to continue drawing, position the template back in place and continue until the transfer is complete.

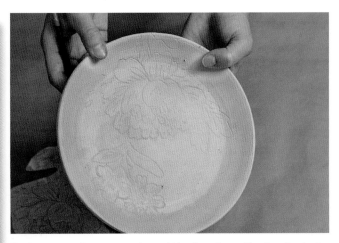

**3.** Once you have transferred the line from the laminated template, you should see a light impression of the line on the surface of your leather-hard ceramic piece.

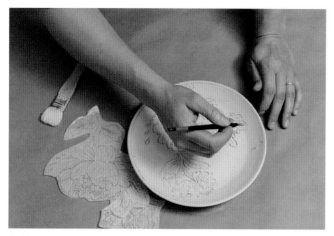

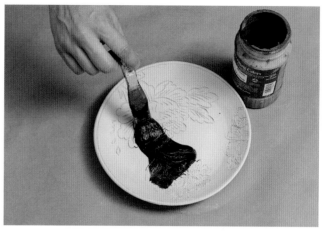

**4.** Using your Hunt calligraphy pen and no. 107 nib, draw into the clay surface over the lines you transferred. You shouldn't need to draw too deeply, because mishima works even with fine lines if wiped gently. If you wipe with a light touch and a very clean sponge, you can retain a lot of fine detail. If you draw into the clay surface with a strong or deep line, you can be more aggressive in wiping the surface after adding the underglaze or slip in step 6. The calligraphy pen should move easily over the dry leather-hard clay, allowing for a flowing line.

**6.** Paint a layer of underglaze or slip over the whole piece using the other hake brush. You may apply the underglaze or slip over the areas where you have drawn, but this may cause the piece to dry unevenly and crack. To avoid this problem, cover the entire surface of the piece with the color you will be wiping off so that it dries evenly. Apply the underglaze or slip before the piece gets too dry. If the piece is close to bone dry, adding the extra moisture from the underglaze or slip will likely cause it to crack.

With the mishima technique, I can water down the commercial underglazes I use by about 50 percent, which allows for the underglaze to be pulled into the drawn lines more easily and saves underglaze. Once you have painted the piece with one coat of the underglaze or slip, let it air-dry back to a dry leather-hard state before you move on to the next step of wiping your surface. This is an important step because if you wipe your pot too soon after applying the underglaze, there will be lots of streaking of underglaze or slip on the surface of the piece.

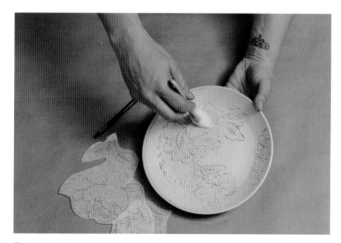

**5.** Use a clean, dry 1" (2.5 cm) hake brush to brush away the crumbs of clay on the surface of the piece. Some crumbs may remain in the drawn lines even after brushing them off. This is okay and part of the look of mishima. Don't fuss over the crumbs, because you will be wiping the clay surface, and that will remove any potentially sharp burrs.

# TIPS

If you find that when you sponge the surface of your clay there are lots of streaks or you are wiping away lines, let the piece dry back to a dry leather-hard state. Also, double-check that your water is clean. If not, change your water and try wiping again. Using a soft natural sponge is important to achieve a good result when wiping your work. The sponge should be clean—so rotate it in your hand as you wipe to ensure that you are wiping with a clean surface each time. This means a lot of rinsing out of the sponge, but the extra effort is well worth the gorgeous results!

If there is still streaking once you have wiped your piece and you are concerned about it showing, let the piece dry to bone dry. Then sand the surface gently with a green kitchen scrubby such as a Scotch-Brite pad. This will smooth out the surface as well as remove an additional layer of the surface—doing away with any streaking! Be safe and wear a dust mask while sanding.

When glazing mishima work, remember to wipe off any dust from previous sanding before you apply underglaze or glaze to the bisqued mishima piece. The dust from sanding will cause crawling in the glazed surface. To remove dust, use a clean, damp sponge.

Often the mishima line that you have inlaid will sit a bit below the surface of the clay. This can result in pinholes in the glaze surface because air gets trapped in glazing. One way to avoid this is by gently rubbing the glaze surface before loading the work into your kiln for glaze firing. This pushes the glaze into any holes that appear and seals them.

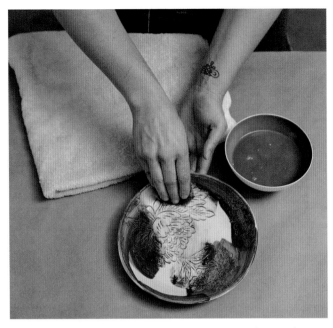

**7.** Using a clean, damp natural sponge, wipe the top layer of the underglaze off of the piece. The result should be a contrast between the slip inlaid in the drawn line and the clay body.

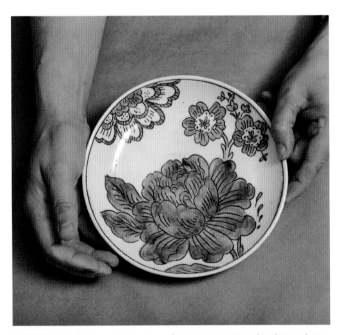

**8.** To finish your mishima surface, use a simple clear glaze over the bisqued piece and fire your clay body to maturing temperature.

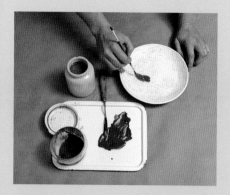

# TRY IT!

After the piece has been bisque fired, paint a layer of underglaze color using the mishima inlaid lines as your guide. Do this before you add clear glaze. This is a satisfying process—like coloring in a coloring book!

# TIPS

If you apply underglaze to the base of your bisqued mishima piece, you will need to wax the bottom to avoid wiping off your underglaze decoration once glazed.

After dipping your bisqued mishima piece in glaze, you might notice that the spots where you have applied areas of underglaze, after bisque do not soak up as much glaze as the rest of your surface. Using a clean, 1" (2.5 cm) hake brush, brush on a layer of glaze over the areas you painted with underglaze. Now the underglazed areas will have enough glaze to retain the same shiny surface as the rest of your piece once it is glaze fired.

# TRY IT!

Painting color in the lines of your mishima surface is exciting, but even more amazing things can happen when you combine the projects outlined in this book on one piece. Try combining the tape resist (page 65) with mishima to make a more complex patterned surface. Add clear glaze over the surface to finish the piece.

# ARTIST INSPIRATION

## Doug Peltzman

Doug Peltzman is a full-time studio potter and teacher in the Hudson Valley area of New York. Doug's work is a wonderful example of how to use the mishima technique to create a dynamic ceramic surface. Doug exhibits his work and teaches workshops nationally. His pottery has been featured in many national publications and can be found in homes across the country.

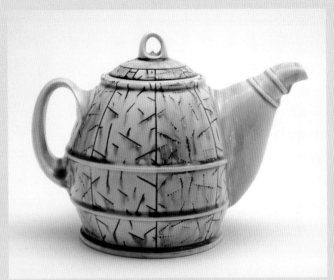

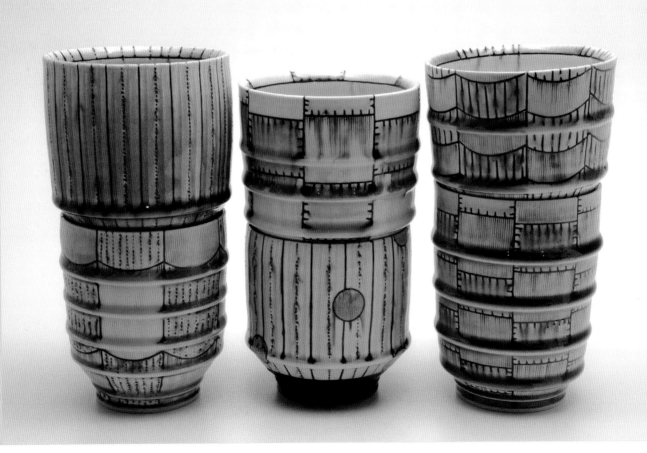

# ARTIST INSPIRATION

## Diana Fayt

Diana Fayt is a modern-day scrimshaw artist whose chosen medium is clay. Drawing on her background as a painter, sculptor, and printmaker, Diana infuses her ceramic surfaces with narrative. Through her use of mishima as well as her self-taught process of etching in clay, shadows of rabbits come alive to play in forests of intricately rendered botanical specimens, exotic sea creatures lurk below antique sailing vessels, and flowers bloom. Diana's work can be found in public and private art collections in the United States and abroad. She has been featured on the cover of *Ceramics Monthly* and in numerous Japanese and American publications. When she is not working in her studio, she can be found teaching technique and inspiring creativity in workshops around the country as well as online at Creativebug and via her self-created online e-course: The Clayer. A graduate of California College of the Arts, Diana currently lives and works in San Francisco with her sweet pooch named Louie.

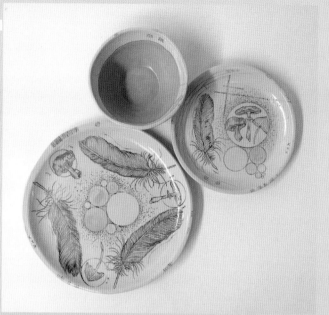

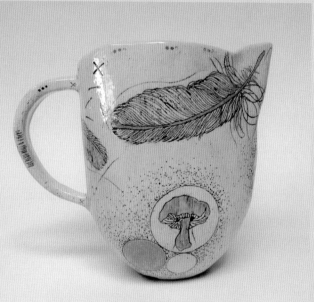

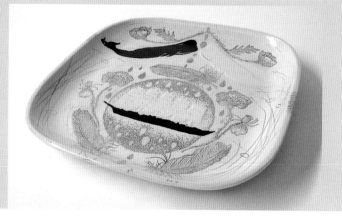

# TAPE RESIST

Masking tape, washi paper tape—these are easily accessible materials and make for a great surface decoration tool on bisque-fired ceramics. I prefer to use washi tape as a resist because it is easy to tear from the roll and remove from the surface of the bisque without leaving a residue behind. Most often, I use washi tape to create stripes in my work. It leaves a clean line with little to no cleanup required. Using washi tape as a resist is an easy way to get a straight line or controlled curved line on the ceramic surface. Using tape as a resist in ceramics is similar to using painter's tape when masking off edges on a wall when painting your home. Use it to block out areas of decoration or to designate a clear edge when decorating work. The uses for tape as a resist are infinite!

## Tools

bisqued ceramic surface

sponge

pen-style craft knife

self-healing cutting mat

washi tape or masking tape

1" (2.5 cm) paintbrush

underglaze

clear or tinted glaze

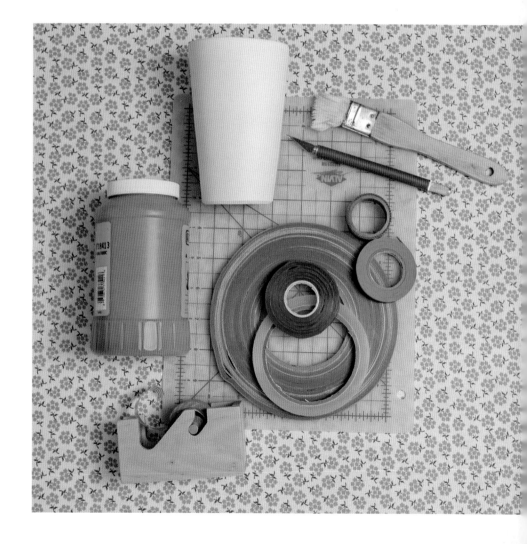

**1.** Clean your bisque piece with a damp sponge to remove any dust from the surface. This will help the tape stick and prep the piece for underglaze and glaze.

**2.** Using a craft knife and cutting mat, cut a length of tape that will fit the length of the surface of the form that you wish to block. Trim the tape if needed. You are using the washi tape as a resist, so wherever you put it on the surface, it will prevent the underglaze from soaking into the clay.

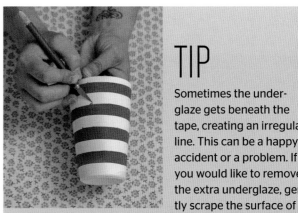

## TIP

Sometimes the under-glaze gets beneath the tape, creating an irregular line. This can be a happy accident or a problem. If you would like to remove the extra underglaze, gently scrape the surface of the bisque using the tip of a craft knife blade or a spear-tipped sgraffito tool. This will easily remove any spots.

**3.** When taping the clean bisque, smooth the tape onto the surface carefully; it may buckle as it moves over the surface. Wherever the tape buckles or creases, there is a good chance that underglaze will seep under the tape and require cleanup.

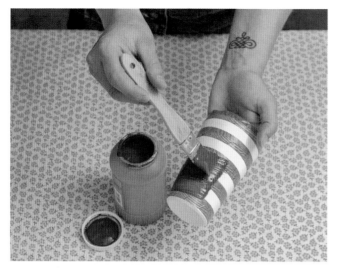

**4.** Once the tape is in place, paint your full-strength under-glaze color over the surface of the bisque. Apply two or three coats to achieve a solid, nonstreaky color, allowing the underglaze to dry between coats. If you want brush-strokes or a more watercolor-like surface, apply one coat.

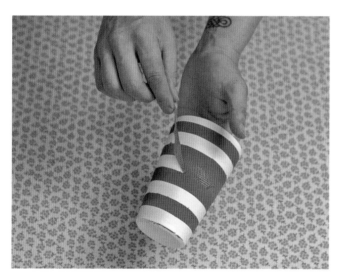

**5.** Allow the underglaze to dry fully. Then carefully remove the tape to reveal the stripe. Finish the piece with a clear or tinted glaze.

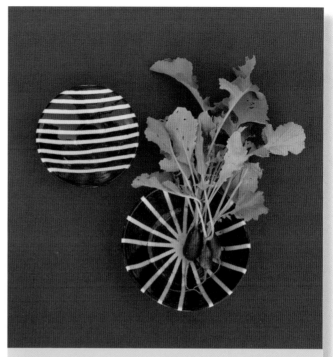

# TRY IT!

Try using the tape as you would use painter's tape—to create a straight edge to a field of color. This can be a great way to color block on a form. You can also try cutting a wavy shape into the tape for a clean line that isn't as straight. You can get creative here. Alter the tape by cutting it into an asymmetric form. You could even create a grid or check pattern by layering the tape.

# ARTIST INSPIRATION

## Alex Reed

Alex Reed is a talented ceramic artist and designer who does design and prototyping for industry. Alex began at Rookwood Pottery of Cincinnati, and he currently works for Heath Ceramics in Los Angeles. He received his BFA from Alfred University and upon graduating, he was awarded a Fogelberg Fellowship from the Northern Clay Center in Minneapolis.

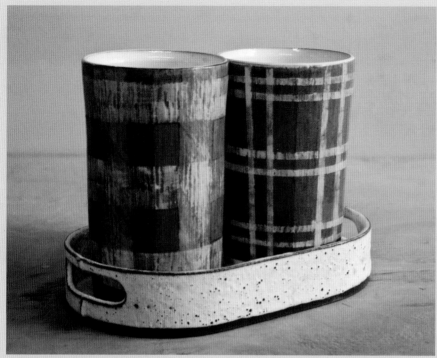

**Alex states:** "Tape is a ubiquitous material in the ceramics studio. It offers an endless, ready-made structure that I can quickly respond to. I use it as a glaze resist to make woven patterns, or I cut out shapes for a stencil to quickly brush color into. Using this inexpensive material allows me to work quickly, while providing just enough framework."

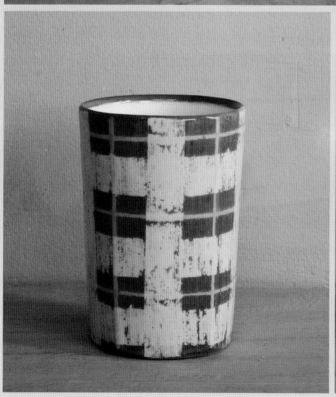

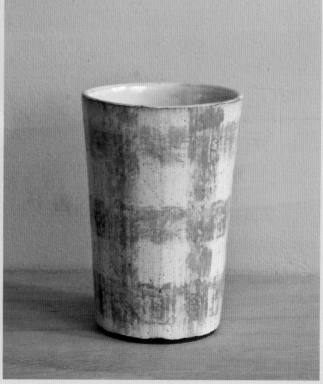

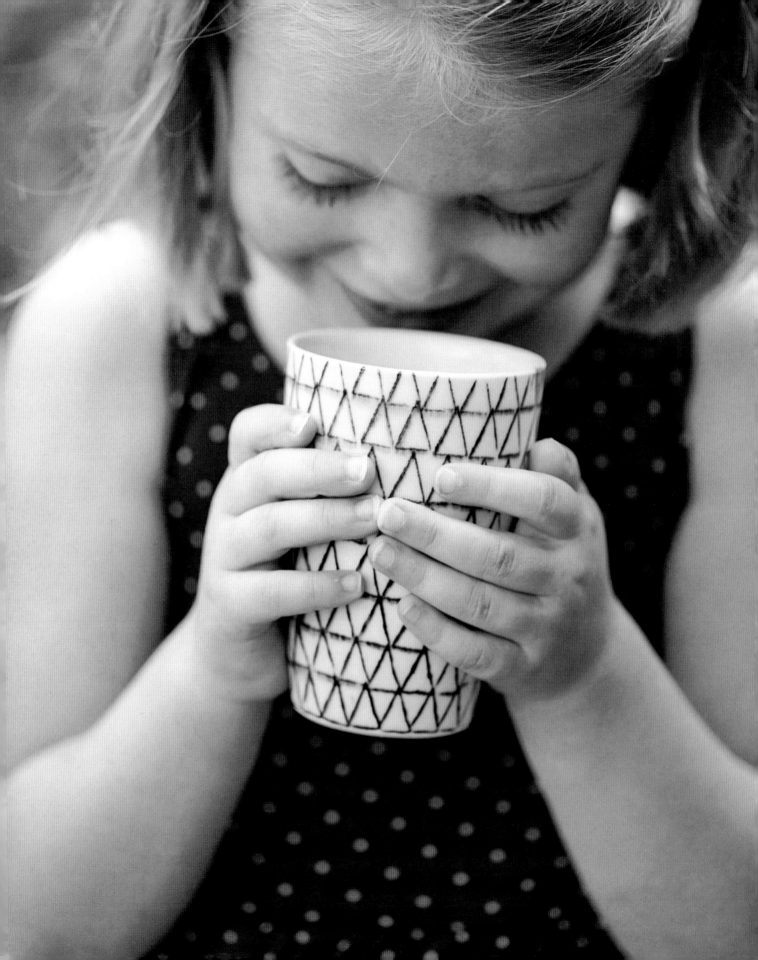

# RUBBER STAMPING

I have loved rubber stamps for as long as I can remember, always somehow finding my way to rubber stamp displays at art supply stores. If you are like me, you have a collection of unused rubber stamps that have been waiting for just the right project. The imperfection of the print is charming, and the process is so simple—great for the surface of ceramics. I developed this rubber-stamping process when working on a large-scale project that required 500 signed pieces. I needed a quick and easy way to stamp each piece with a number. As a result, I figured out how to make my own ceramic stamp pad using materials I had on hand in my studio.

## Tools

two synthetic sponges, one damp and one dry

bisqued ceramic surface

underglaze

hake brush

selection of rubber stamps

paper

clear or tinted glaze

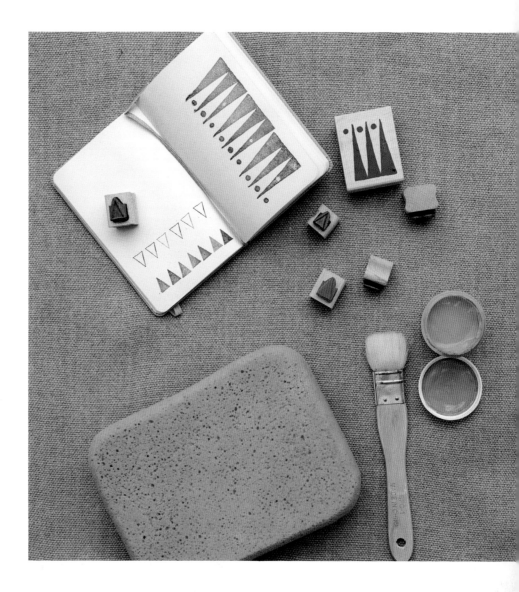

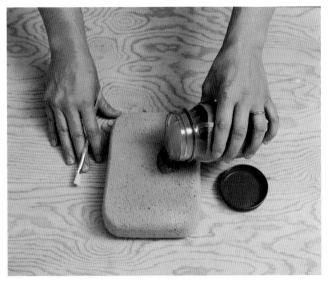

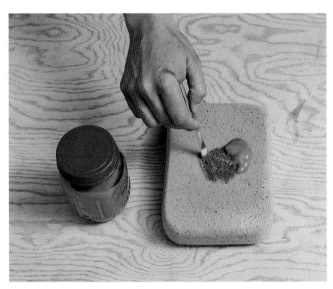

**1.** Use the damp sponge to wipe the bisqued ceramic surface clear of any dust. The dry synthetic sponge will be used as a "stamp pad" for this project. To make the sponge "stamp pad," slowly pour a dollop of underglaze onto the center of the sponge.

**2.** Use any brush you have on hand to blend the underglaze dollop into the sponge until it is fully absorbed, creating a ceramic stamp pad. Use this area for "inking" your stamps.

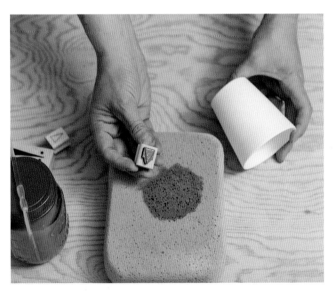

**3.** Gently "ink" your rubber stamp by pressing it into the surface of the sponge ink pad. With a brand-new stamp that you haven't used with underglaze before, it may take a few tries to get it properly inked. Test the stamp on paper to see how it works before stamping your work.

# TIP

If you want a more detailed stamp with a layer of color behind it, ink your stamp with *regular* inkpad ink and stamp this on the bisqued surface. The image will give you a guide as to where to put color, but because it's regular ink, it will burn out in the firing process and disappear! Simply paint the color where you'd like it to appear in the stamped image, ink your stamp with your ceramic stamp pad, and place the stamp over the color, taking care to register the image as closely as possible.

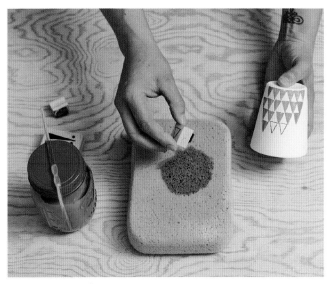

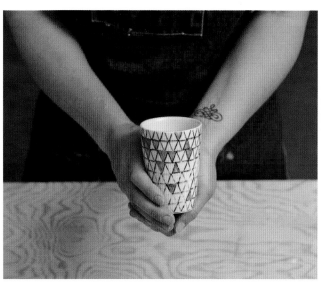

**4.** Place the "inked" stamp onto the clean bisqued surface and remove. You have stamped your ceramic surface!

**5.** Simply finish with a clear or tinted glaze.

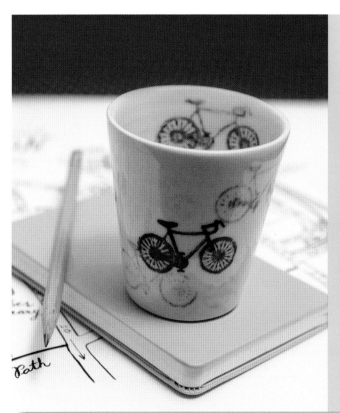

# TRY IT!

Try stamping over artwork that you have added to the surface of your ceramics using different surface techniques. Like stamping on paper, stamping on clay can be a wonderful way to layer information in an image. Experiment with underglazes and layer stamped imagery with different color "inks"!

Recently, I have explored having custom stamps made from my artwork. I have found that it is straightforward to upload my scanned artwork to a custom stamp website and have it made into my own rubber stamp. It is really exciting to see your artwork as a rubber stamp (see "Rubber Stamps" on page 151) and it is affordable to do. As a result, I am stamping everything in the studio! Try sending scans of your artwork to be made into your own custom stamps or use the templates on page 144.

# ARTIST INSPIRATION

## Rae Dunn

Rae Dunn accidentally discovered clay in 1994, and it slowly took over her life until it became her life. She has a BA in industrial design and worked in graphic and fashion design before turning to clay. From the very start, her love of text and simplicity seamlessly translated into her ceramics. The Rae Dunn pottery line, which was primarily wares with text and images imprinted into the clay, was started in 1996. Her pottery is currently being sold nationwide and in many other parts of the world.

**Rae states:** "The technique I use to imprint text into clay is very straightforward. Once the clay is about halfway dry, I take a metal or rubber stamp and press the letters into the clay. After the bisque firing, I paint underglaze into the indentations and wipe off the excess with a wet sponge. I then add a clear glaze and fire to temperature."

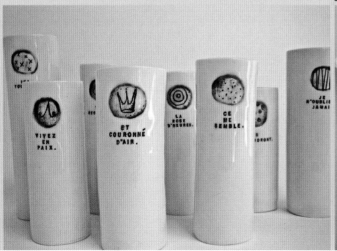

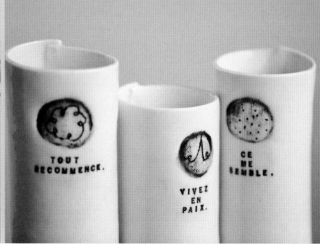

# ARTIST INSPIRATION

## Brenda Quinn

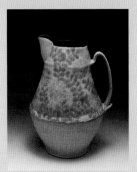

Brenda Quinn received an MFA from Southern Illinois University Carbondale and a BFA from Tyler School of Art at Temple University. Brenda currently teaches ceramics and visual arts at the Fieldston School in the Bronx, New York. Her work has been exhibited both nationally and internationally. She is obsessed with learning new techniques and loves how a different process can breathe new life into familiar forms and patterns. Brenda maintains a studio in her home in Mt. Vernon, New York, with her husband, two daughters, three cats, two guinea pigs, and four chickens.

**Brenda states:** "The surfaces of my work are created through a variety of processes. The surfaces of the pieces here use stamping in some way. I create stamps out of furniture foam, which acts like a sponge. After drawing a design on the foam with a marker, I then cut the foam using scissors and/or a soldering iron. I stamp underglaze and glaze on greenware and bisqueware."

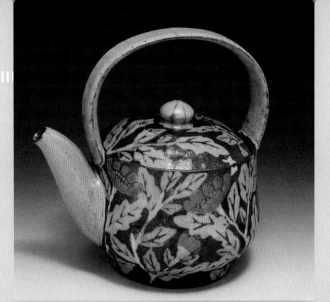

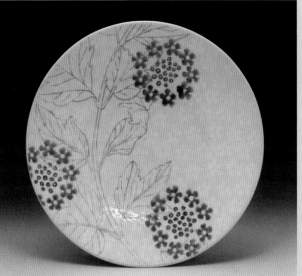

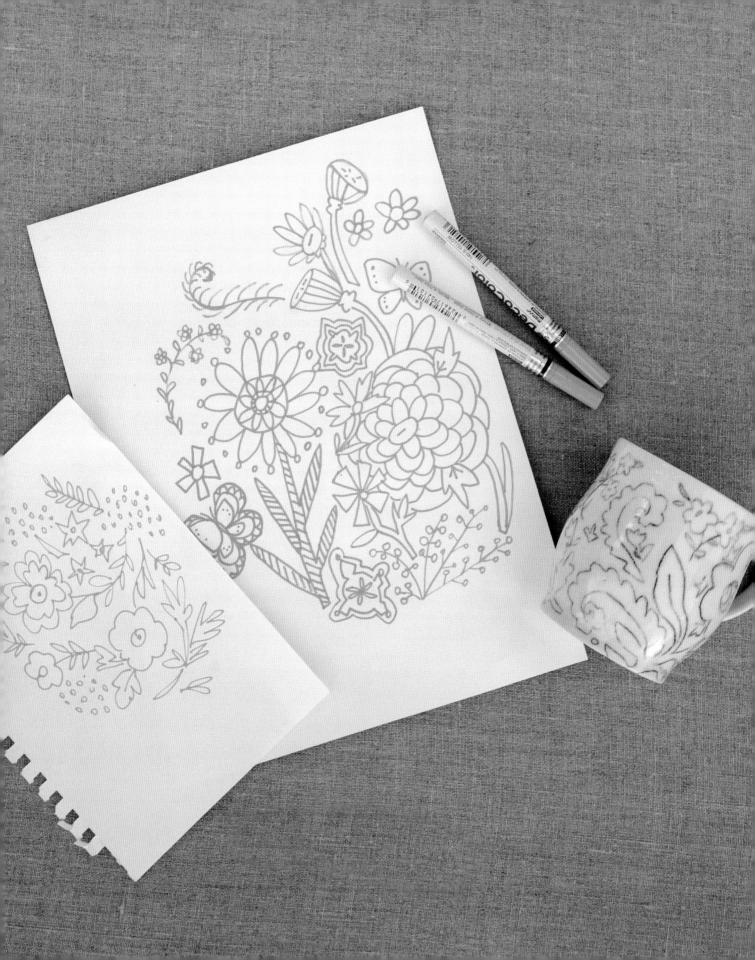

# DOODLE

Doodling on the ceramic surface can be as satisfying as doodling on paper. Drawing from your imagination and responding to the form you are drawing on can have fantastic results and lead to new artwork ideas. Doodling on clay is a great warm-up exercise, but it can also become a large part of your work. If you find that you doodle in your spare time with a paper and pen, then this project will come naturally. Doodling is a great way to work on a surface a little at a time. You can put it down and return to it later. Consider doodling on clay a work that progresses over time rather trying to complete your doodle in one sitting. Remember, there are no mistakes in doodling. This is a great place to start, and with exciting tools such as the underglaze pencil, you can even achieve the look of pencil on paper but on the clay surface!

## Tools

bisque ceramic surface

400-grit sandpaper (optional)

damp sponge

underglaze pencil

pencil sharpener

clear glaze

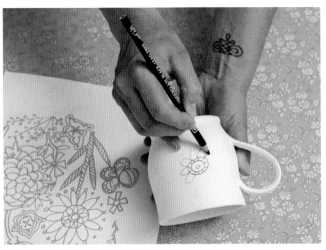

**1.** Start with a clean bisque ceramic surface. If you find that your bisque surface is a bit rough, consider sanding it with a fine-grit sandpaper (400 grit would do it!). Sanding the bisque will create a nice smooth drawing surface. Wipe the sanded surface with a damp sponge to remove any dust before starting your doodle.

**2.** Drawing from your imagination or from gathered sources of inspiration, use an underglaze pencil to start your doodle, beginning with the center point of the piece or a focal point. (The focal point can be off center.) Another good place to start is at the edge of the form. If you are stumped, try starting with a geometric shape or a simple line and build your doodle from there. You can't go wrong when doodling!

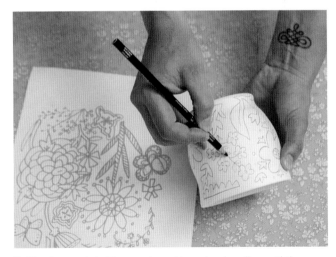

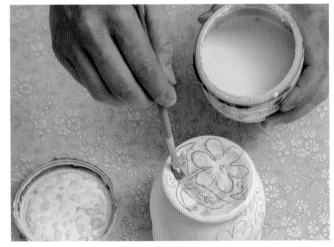

**3.** Trust your intuition and continue to doodle until the piece feels "done." If doodling is new to you, try starting with basic shapes (circle, square, triangle) and repeat them freehand until the surface feels finished. Don't forget that you can doodle inside and on the bottom of your piece, too! If you doodled on the bottom of your piece, wax the bottom.

**4.** Finish your piece by dipping it in clear glaze.

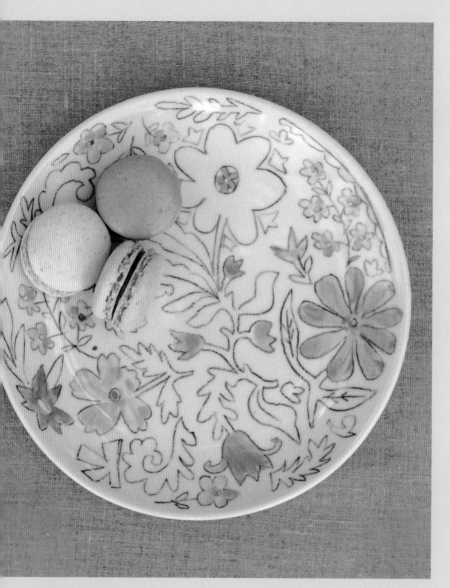

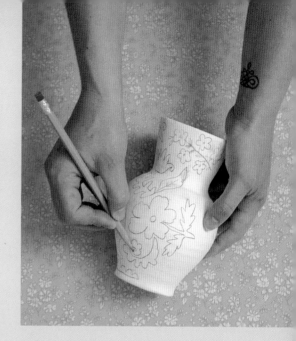

# TRY IT!

Not sure where to start? Use the doodle prompts on page 145. Cut up the word prompts and place them in a bowl. Pull out a prompt and do an imagery free-association exercise in response to the prompt, doodling whatever comes to mind on your ceramic surface. Continue with one prompt until your piece is complete, or select new prompts when you are ready for more inspiration! Alternatively, create a chart of your own prompts to use for inspiration.

# TRY IT!

Adding points of interest can make for fun variations in your doodle—like adding color to stripes or dots and filling in parts of the drawing but not necessarily all of it. You can fill in areas with your underglaze pencil or add color to your doodle lines by painting on underglaze in sections using a small detail brush.

Try doodling on a bisque ceramic surface with a no. 2 pencil before tracing over it with your underglaze pencil. You can erase the no. 2 pencil and actually shift your drawing a bit before committing to the final image. You can also color in areas of your sketch before finishing off the doodle surface with an outline of the underglaze pencil.

# ARTIST INSPIRATION

## Hannah Niswonger

Hannah Niswonger attended Wesleyan University in Connecticut, where she received a BA in studio art. She received an MFA in ceramic sculpture from Alfred University in New York. Hannah has taught courses in ceramics at many universities, and she exhibits her work nationally in galleries and at prestigious craft shows, such as the Philadelphia Museum of Art Show and the Smithsonian Craft Show. A founding member of POW! (Pots On Wheels), a collaborative mobile outreach gallery project, Hannah lives in Winchester, Massachusetts, with her husband, three kids, dog, and several fish.

**Hannah states:** "All of my work is hand-built from slabs of clay. The pots are sewn together, scored along the edges, and then nipped and tucked together to make rounded forms from sheets of clay. Using a Chinese calligraphy brush, I paint on bone-dry pots with underglaze stains, which act like an ink wash or watercolors on the absorbent surface of the clay. I scratch and carve into the drawings, adding and removing details. The pin tool is both pencil and eraser, adding white to the drawing. I use wax to create motifs that are reminiscent of printed patterns. Pattern and color anchor my animals to the pots. They serve as frames and backgrounds, so that the animals exist in their own narrow space around the pots."

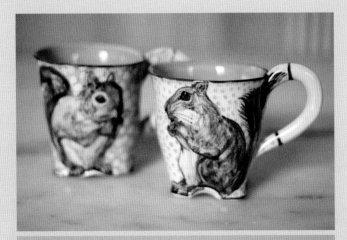

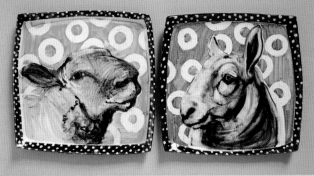

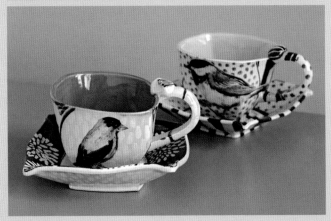

# ARTIST INSPIRATION

## Brooke Noble

Brooke Noble received her BFA from Syracuse University and attended Southern Illinois University for her MFA. Between degrees, she was a resident artist at three studio art centers. Ceramics has taken Brooke to many national and international destinations, and her work has been exhibited in numerous galleries nationwide and published in books and periodicals. Brooke enjoys teaching both adults and children in the Adirondacks as well as traveling around the country to art centers and universities to share her experience.

**Brooke states:** "I draw, carve, stamp, paint, stencil, screenprint, trace, resist, and transfer images in order to activate my pots with bold graphics, patterns, and animal imagery. Birds and animals act as metaphors, and my work embraces humor and irony. As I build upon the layers of composition on each object, often a narrative begins to emerge. By covering every surface, I utilize the bottom of the pot to continue the design or hide a one-liner for the user to discover over time."

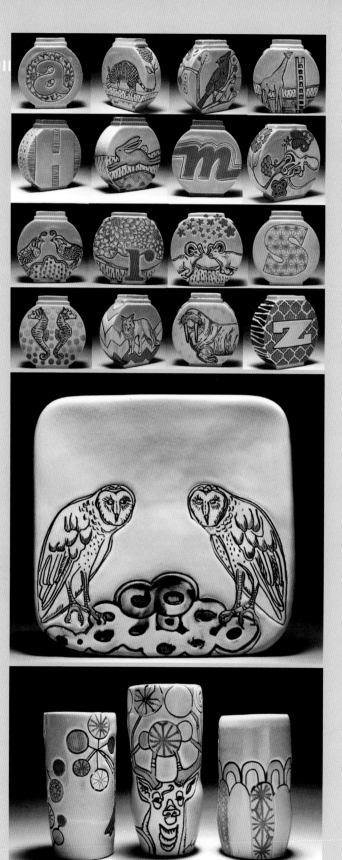

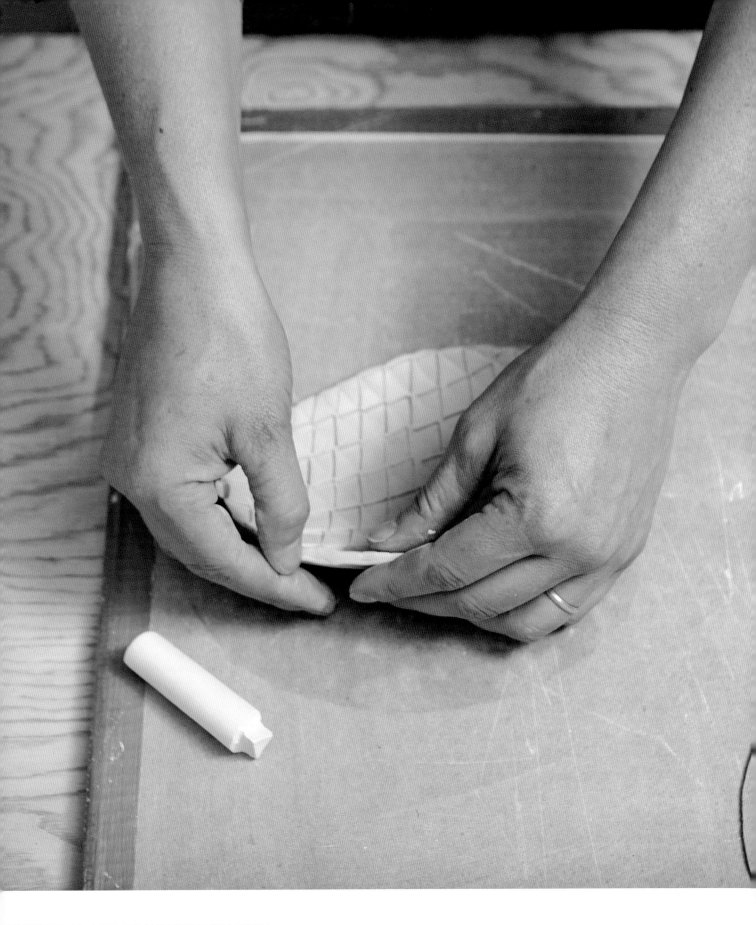

# TEXTURE

One of the advantages of decorating the ceramic surface is the ability to layer texture into your work. Unlike painting or drawing, texture can be deep in the surface of the piece and become a large part of your work. When I first started working in ceramics, I stamped texture into my surfaces as a way to add decoration and to sign my work. Adding texture to your ceramic surface can be a fun way to explore marrying surface and form or it can be a career-long passion. If you have access to atmospheric kilns that use soda, salt, or wood, try them! These firing processes accentuate the surface, bringing out the best textures. The following projects each explore a different way to make textural surfaces on ceramics, from stamping with rubber stamps to using found textures.

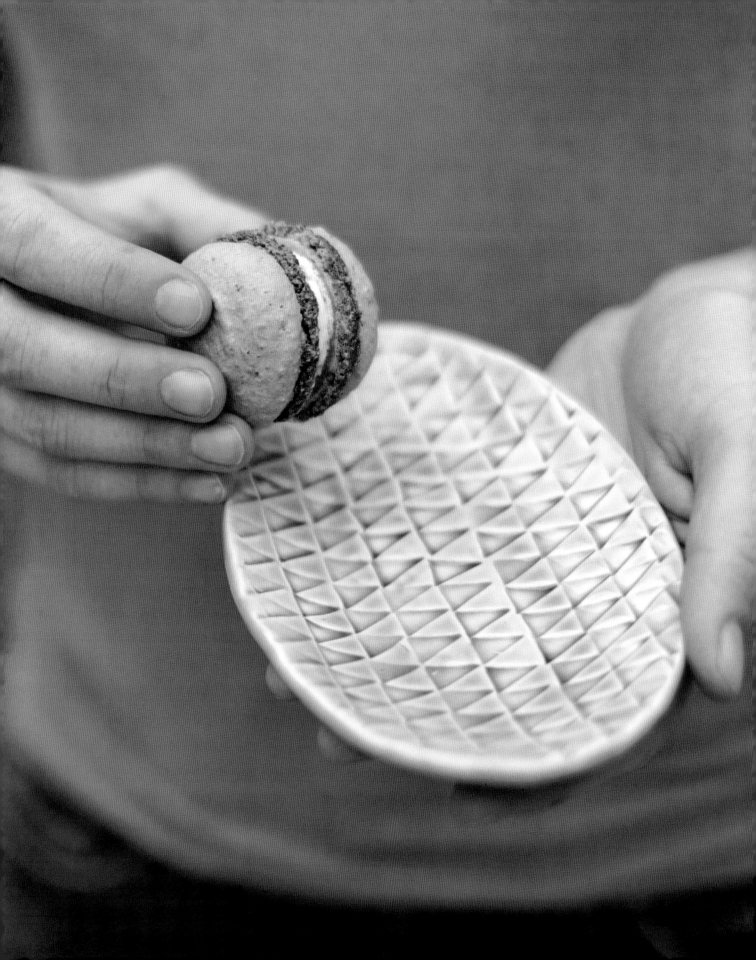

# STAMPING TEXTURE

Creating your own stamp out of clay is an exciting way to add a repeating texture or motif to your surfaces. The first clay stamp I made was of my initials, and I used this stamp to sign my artwork for years. Since making that first stamp, I have explored many uses for stamping on clay. Stamping creates a particular kind of look in the surface of clay. The edges of the stamps are usually a bit loose, and the hand is revealed in subtle imperfections from the stamping process. I love the quirky nature of stamped clay surfaces!

## Tools

small piece of clay, preferably porcelain

pencil

spear-tipped carving tool or carving tool of choice

sanding pad (optional)

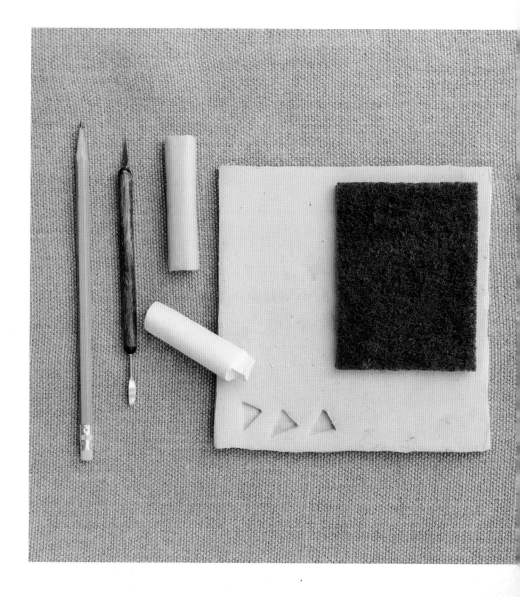

**1.** Mold a piece of soft clay to the shape you desire for the stamp outline. In this case, I have made a round stamp, but you may want the stamp to be triangular—experiment! Allow this stamp blank to dry completely to bone dry.

**2.** Using a pencil, sketch on the surface of the bone-dry stamp blank what you want to carve away. (This will be the negative space in the design.) Keep in mind that what you carve away will be *embossed* (raised or protruding from the surface) on the clay surface and what you do not carve away will be *debossed* (pushed into the surface or a depression in the surface). The image or lettering you carve into the stamp blank will be reversed when you stamp it into the clay surface, so if you want to create a stamp with writing, sketch it onto the stamp backward so the stamp will read correctly.

# TRY IT!

**Try using your found rubber stamps to stamp texture into the surface of your ceramics.**

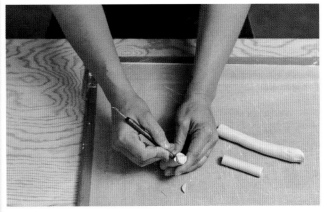

**3.** Use the spear-tipped carving tool to gently cut into the stamp blank until your image is carved. Carefully test your carving on a piece of soft clay to see your progress. Make adjustments to the image as needed. Use the sanding pad at this point or just before bisque firing to remove any sharp edges or burrs from carving your stamp.

**4.** Bisque fire your stamp. To use the stamp, simply press it into the surface of damp clay to create a textured surface. Stamp your ceramic surface while the clay is still quite soft and malleable. If you are stamping on a wheel-thrown piece, consider stamping before you trim your piece or as soon as possible after trimming. If you are handbuilding with a stamped surface, stamp the surface with texture before handbuilding. Stamping into the surface of clay requires a lot of pressure at times, so if you are stamping into the surface of a finished piece, it may warp or change the form dramatically.

# TRY IT!

Try stamping texture on the surface of your clay with found textures—bark from a tree, shells, jewelry. Just about anything with a texture is worth trying!

# TRY IT!

Textured clay offers opportunities for all kinds of glazing. Any transparent or semi-opaque glaze pools nicely in stamped texture and creates an exciting varied surface. Simply dip or brush the tinted glaze over the whole piece and let it work its magic in the kiln. If you have access to a glaze lab, see the Recipes section on page 153 for instructions on mixing your own tinted glazes. On page 150, you will also find sources for a commercial mid-range tinted glaze.

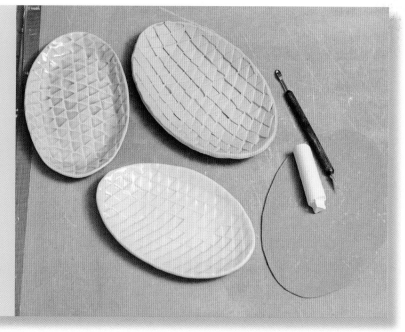

# ARTIST INSPIRATION

## Kristen Kieffer

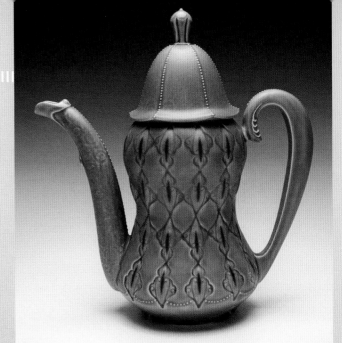

Kristen Kieffer is a full-time studio potter, workshop leader, and ceramics instructor who lives in Massachusetts. She received a BFA in ceramics from the New York State College of Ceramics at Alfred University and an MFA in ceramics from Ohio University. She has been an artist-in-residence with studio potter John Glick in Farmington Hills, Michigan; at Guldagergård in Skælskør, Denmark; and at the Arrowmont School of Arts and Crafts in Gatlinburg, Tennessee. Kristen exhibits her work internationally, and she teaches workshops at craft centers and universities all around North America. Her work is in numerous collections, including the New Taipei City Yingge Ceramics Museum in Taipei, Taiwan; the Fort Wayne Museum of Art in Fort Wayne, Indiana; and the San Angelo Museum of Fine Arts in San Angelo, Texas.

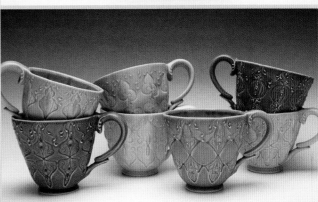

**Kristen states:** "I use dozens of stamps I both design and make to impress into my wheel-thrown forms at a stage I refer to as 'suede.' By stamping at such an early point in the process, I'm able to capture the plasticity of the material, which allows me to simultaneously bring precision, softness, and tactility to the finished forms. The stamp designs come from my own sketches and are influenced by Art Nouveau, Middle Eastern, and other patterns, as well as imagery I just enjoy that can bring an elegant or playful quality to my pots."

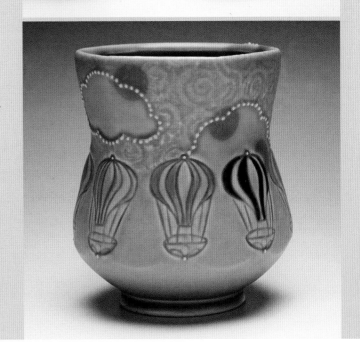

# ARTIST INSPIRATION

## Sunshine Cobb

After a short stint at Chico State University, California, Sunshine Cobb went on to earn a BA in studio art from California State University at Sacramento. She graduated in 2010 from Utah State University with an MFA in ceramics. Sunshine is currently focusing on making functional ware, embracing the richness of red clay, and exploring the challenge of electric firing. Named an emerging artist by both *Ceramics Monthly* and the National Council on Education for the Ceramic Arts, Sunshine works as a potter and travels the country as a lecturing and demonstrating artist. She completed a long-term residency at the Archie Bray Foundation in Helena, Montana, and she is settling in California to set up shop.

**Sunshine states:** "I use a variety of self-made roulette stamps to apply texture in two ways. The first is a straightforward rolled-on application to a slab with a roulette that is about the width of my palm. I then use this either as a bottom slab that I cut into a template for a coil-built form, or I use the slab to construct a soft-slab cup over a bisque mold to preserve the shape and the texture I imprinted on the flat slab. I also apply texture to a thrown form. I do this just after the form is no longer sticky and not yet quite leather-hard. The roulettes I use are about the width of my finger, as I need to backstop each roll on the interior of the pot to ensure I keep the shape of the pot and to get good definition from the roulette."

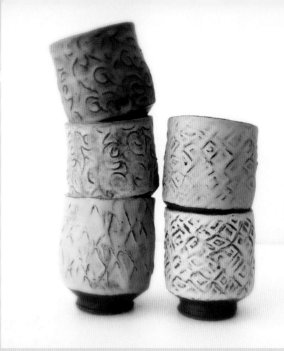

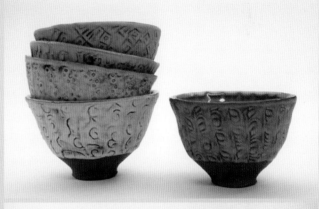

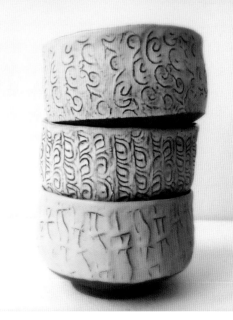

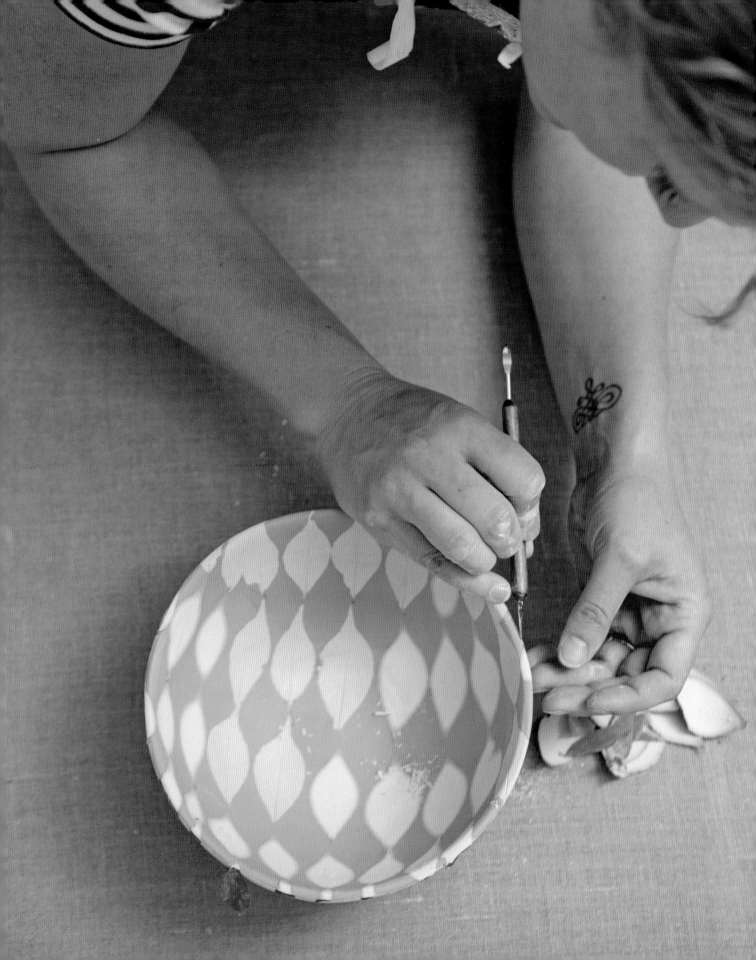

# NATURE RESIST

Nature is inherently beautiful and has been a muse of mine for as long as I can remember. Capturing nature on the ceramic surface is fun to do and creates an instantly attractive surface. You need to have access to live leaves, ferns, and flowers for this project, so summertime is a perfect time of year to try this out. In the middle of the New England winter, when there is snow all around, I love looking at the surfaces I have made using nature resists. They are a reminder of the bounty of summer. This technique allows Mother Nature to do the drawing for you!

## Tools

leather-hard or softer greenware form

gathered textures, fresh flowers, and leaves

sponge

spray bottle filled with water

ceramic brayer or small rubber ball

1" (2.5 cm) brush

slip or underglaze

spear-tipped sgraffito tool

clear glaze

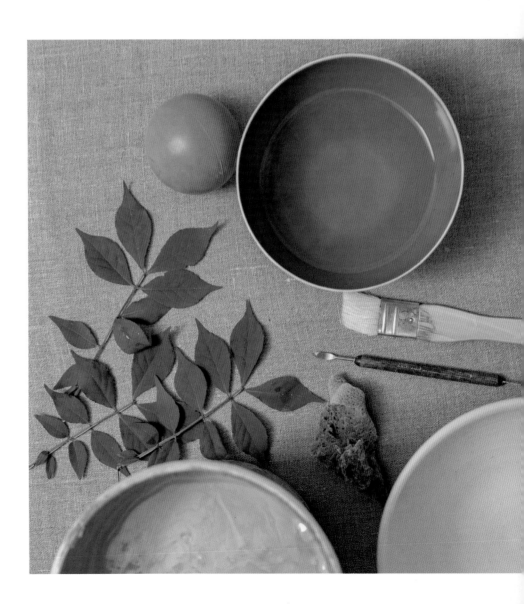

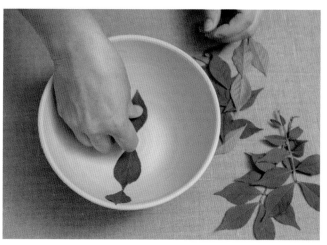

**1.** This project works best on fresh, malleable clay. Work on a freshly made piece that is still fairly soft or a thrown pot right after it is trimmed. Gather your leaves or other natural items to use as a resist. Be sure to get live, green leaves and flowers to use, because they are the most flexible, will adhere nicely to the clay surface, and can be easily removed. Dried leaves are too brittle for this technique and will break.

**2.** Position the leaves as desired on the surface of your leather-hard or softer form.

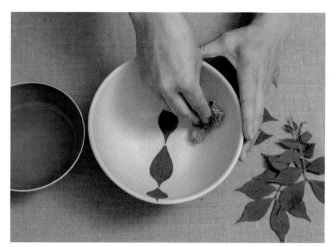

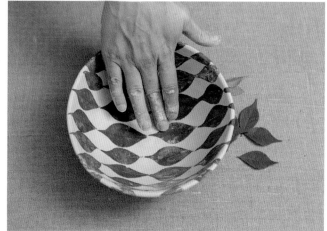

**3.** Gently press each leaf into the surface of the clay. The veins of the leaf will create an impressed texture. If the leaf isn't sticking, wet the surface of the clay with a damp sponge just before applying the leaf or by lightly wetting the surface with a spray bottle. Use the brayer to roll the leaf onto the clay surface or, if you are applying the leaf to a rounded surface such as the interior of a bowl, try rolling a rubber ball over the leaf to press it into the surface.

**4.** Use your fingers or a damp sponge to smooth out each leaf so it conforms nicely to the shape of the form. Try to press the leaf into the clay enough so that there are no spots where the leaf buckles or sticks up. This is important, because if the leaf isn't sealed to the clay surface in all areas, underglaze or slip will seep underneath, requiring cleanup after you remove the leaf.

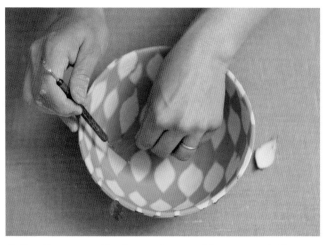

**5.** Using a 1" (2.5 cm) brush, apply a thick layer of slip or underglaze over the surface of the leaf and the clay. Allow the piece to dry back to a leather-hard state, so the underglaze is no longer wet to the touch.

**6.** Gently remove the leaves to reveal the resisted silhouettes and impressed texture they leave behind.

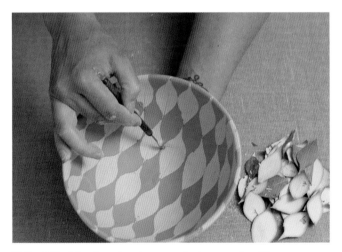

# TRY IT!

Try coating the ceramic surface with a layer of underglaze or slip before adding the leaves to the surface. After it dries enough to touch without the slip sticking to your finger, place the leaves over this layer of slip or underglaze and then add a second color. This technique creates a multilayered surface decoration with contrasting colors of slip or underglaze, making your leaf pattern "pop" on the surface!

**7.** If a little bit of underglaze or slip has worked its way under the edges of the leaves, use your spear-tipped tool to gently scrape away the slip that you do not want on the surface. Allow the piece to dry, and then bisque fire and finish with a clear glaze.

# ARTIST INSPIRATION

**Evelyn Snyder**

Evelyn Snyder makes functional pottery with designs that reflect the beauty of the natural world. Using a technique she learned from her friend and mentor, Kathy Hibshman, Evelyn collects local leaves and uses them to create designs and patterns on stoneware slabs. These are by nature one-of-a-kind, because no two leaves are identical, and no leaf can be reused. Evelyn exhibits her wares at galleries and craft shows nationally. She works from her studio in Easthampton, Massachusetts, where she employs two part-time assistants.

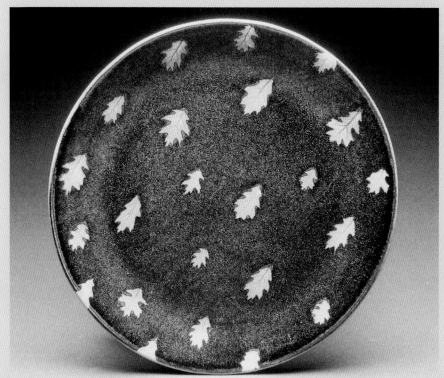

**Evelyn states:** "Using real leaves to create patterns involves finding the right leaves. The size of the leaf is important, and it is much harder to find leaves that are small enough. I focus most on the lines and negative space the leaves create than on the individual leaves. I prefer quiet spaces in most of my designs. I do make busier patterns on occasion. Working with real leaves in New England means working seasonally. In the fall, I harvest and freeze thousands of leaves. In the spring, hundreds of tiny fresh leaves of the same size come out, seemingly in the span of a day or two. That is when I am most compelled to make what I call "wallpaper" designs, with the leaves functioning almost like polka dots to form a pattern."

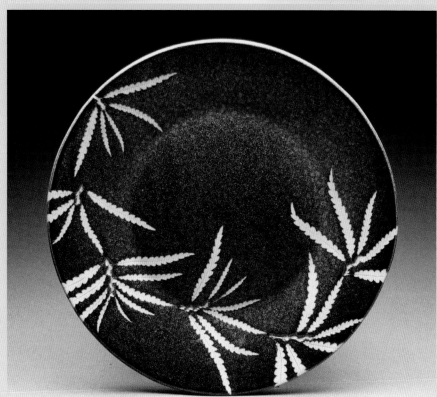

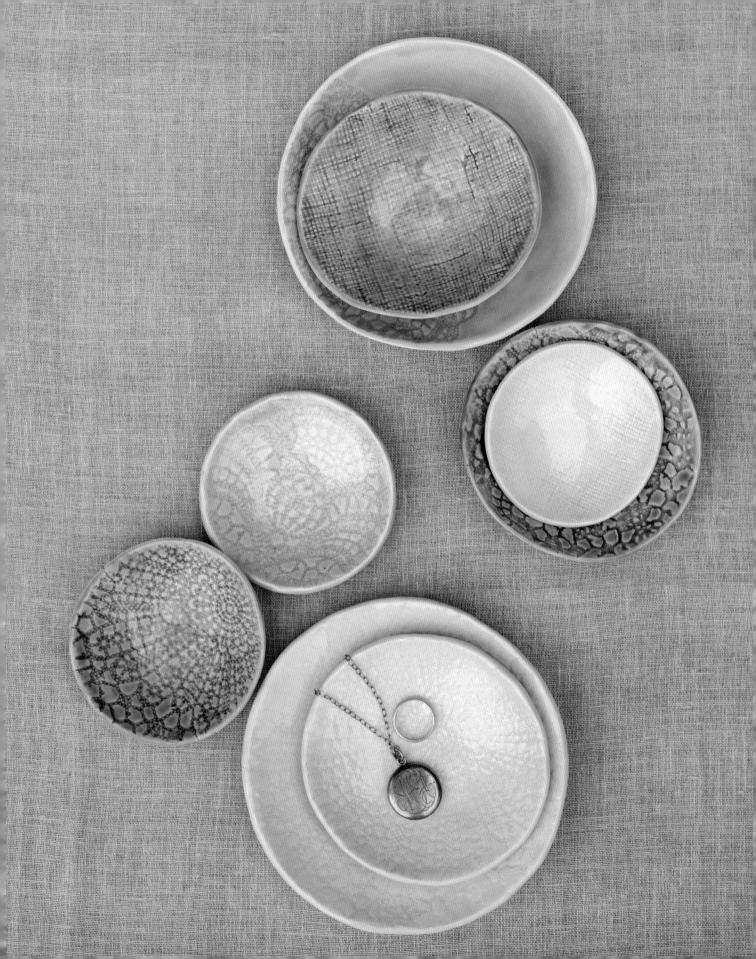

# FOUND TEXTURE

Ceramics is a great medium for creating a textural surface. At yard sales and flea markets, I always find amazing textures for the surfaces of clay. This project will walk you through using a found material texture on the ceramic surface. Fabric is an ideal material for creating texture because it is so flexible and easy to come by. Keep an eye out for old lace, burlap bags, place mats, plastic and crocheted doilies, and even knits. One of the most exciting parts of this project is the hunt for good texture!

## Tools

rolling pin, brayer, or ceramic hand-roller tool

damp leather-hard slab

found texture

laminated tracing transfer (page 53) from circular paper template (page 146)

pin tool

finished bowl

newspaper

green scrubbing pad

clear or tinted glaze

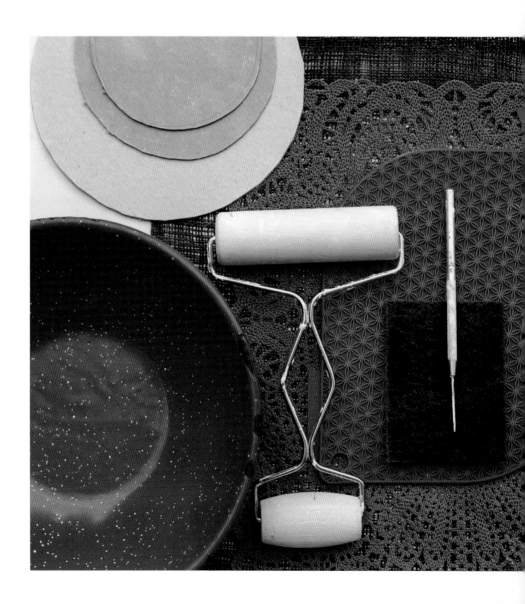

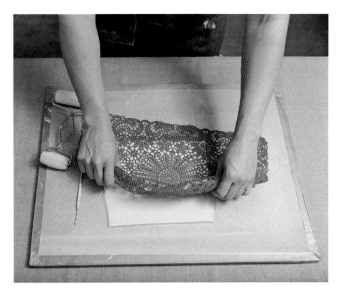

**1.** Use a rolling pin, brayer, or ceramic hand-roller tool to roll a clay slab that is large enough to fit the paper template or shape of your choice and arrange your found texture on the surface. In this case, I am making a small round dish, so I also have a round laminated paper template (see Templates, page 146) that I'll cut the dish from once I've applied the texture.

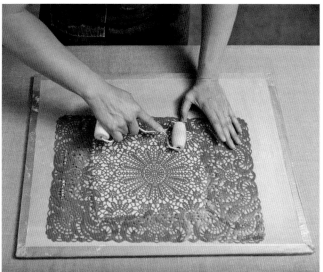

**2.** Hold the texture in place with one hand and gently roll over it with the brayer or rolling pin until the fabric is pressed into the surface of the piece. If you have very thick fabric with a potentially deep impression, be careful not to roll your texture through your slab. It is easy to add too much pressure when rolling.

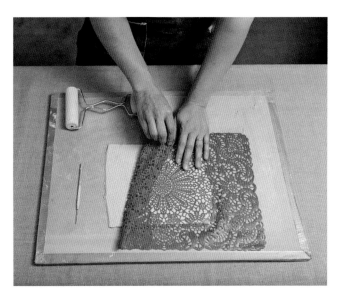

**3.** Remove the fabric to reveal your surface texture print!

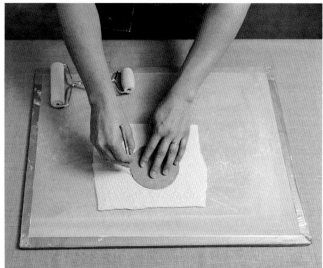

**4.** Lay your circular paper template over the textured slab and, using a pin tool, trace and cut along the edge of the template to make a round dish shape.

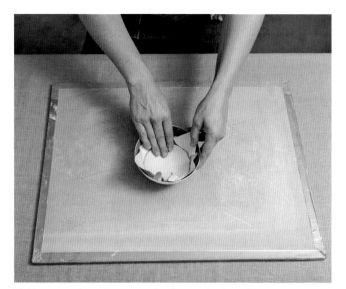

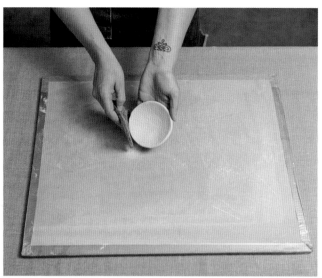

**5.** Use your hands to gently shape the bowl, not worrying too much about the rough edge from cutting because it will be sanded later. Line an existing bowl with newspaper and lay the piece inside of it. The bowl provides support, allowing the piece to retain a bowl shape as it dries.

**6.** Once the pot is bone dry, remove it from the bowl and gently sand the edges with a green scrubbing pad before firing in bisque. Finish the piece with a clear or tinted glaze.

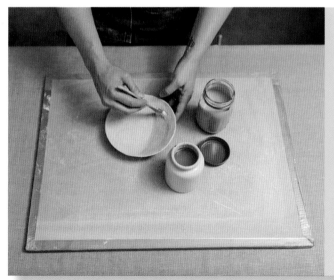

# TRY IT!

Try applying a layer of a colored underglaze to the surface of the texture you have pressed into your ceramic surface. Let the underglaze dry to bone dry and gently sand away some of the underglaze back to the clay body. The underglaze will stay in the cracks and crevices of the texture from the fabric, making the pattern on the surface pop!

# ARTIST INSPIRATION

## Sandi Pierantozzi

Sandi Pierantozzi works from her Philadelphia studio with her partner, Neil. Sandi and Neil have worked hard to maintain as efficient and sustainable a studio practice as possible, focusing on recycling as much material as they can, reducing their carbon footprint by using wind-generated electricity, and living within walking distance of their studio. Sandi's work has been widely exhibited and collected, and her career has included multiple board memberships, residencies, and fellowships.

**Sandi states:** "My current work involves a combination of impressed texture, carving, oxide washes, colored slips, and slip trailing. Most of my pots are handbuilt from slabs that I make with a rolling pin. After rolling a slab, I either texture the clay as a flat surface and then make a cylinder, or I carve into the clay after the form is made. With this method of working, I can make pots that reveal the soft qualities of clay through the impression of texture, while at the same time show control of the clay through the forms."

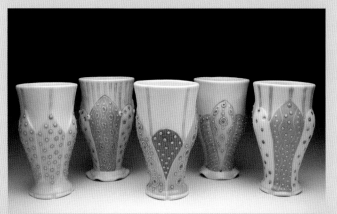

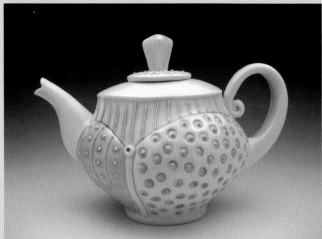

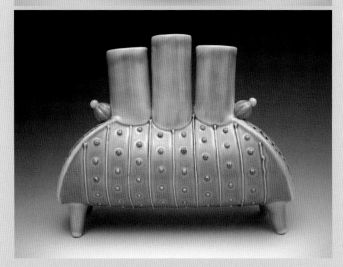

# ARTIST INSPIRATION

## Chandra DeBuse

Chandra DeBuse is a full-time studio potter and educator residing in Kansas City, Missouri. Her candy-colored ceramic service ware incorporates narrative imagery, pattern, and form to amuse and delight the user, imparting a sense of play. Chandra's work is widely exhibited nationally, and she teaches many workshops.

**Chandra states:** "I utilize surface texture as low-relief imagery on my functional pieces, which encourages a sense of discovery and exploration. For example, the two-dimensional botanical imagery I create on the surface of a server becomes a three-dimensional pocket for a golden spoon. I see my pots as landscapes where human fingers are invited to roam alongside my hand-drawn characters, each seeking out their own morsels of delight. Only through using the work—holding it, inspecting it—can the whole image or pattern be understood."

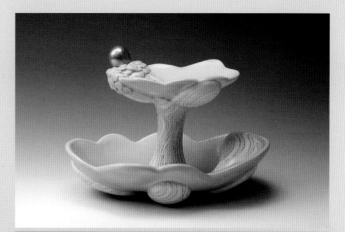

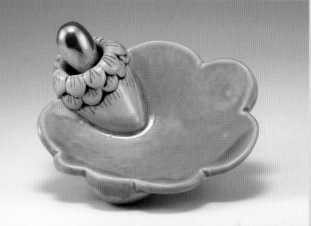

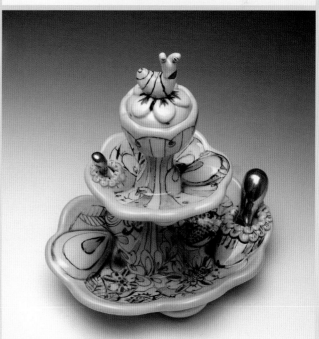

# SHELLAC RESIST

This technique is one of my favorites to demonstrate when teaching because it has a magical "reveal" moment when you first start wiping the surface of the clay to see the texture left behind by the shellac. Shellac hardens fast, so you must work quickly with this technique. As with other textural projects in this book, tinted clear glaze looks fantastic because it pools in the surface. If you have access to atmospheric kilns, use one for this technique; the raised texture looks incredible in wood and salt firings. Shellac resist is also a great layering technique to use with other projects in this book.

## Tools

laminated tracing paper transfer (page 53) from template (page 147)

stylus

leather-hard greenware ceramic surface

shellac

small brush

denatured alcohol

sponge

bucket of water

clear glaze

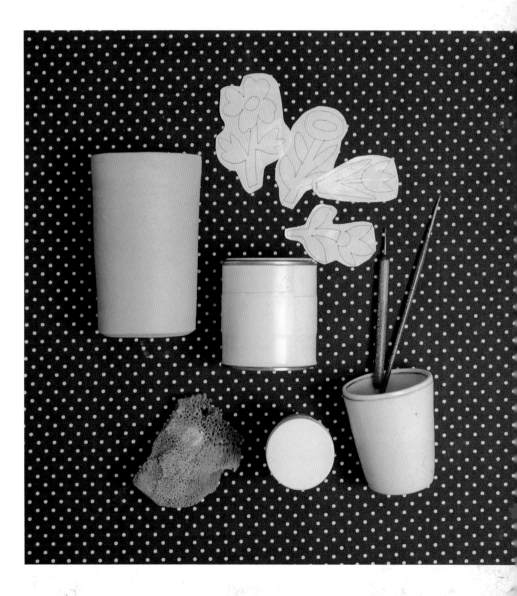

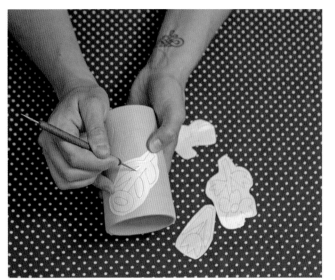

**1.** Using a transfer and a stylus, transfer your image onto the leather-hard ceramic surface or draw your design free-hand. You will use this transfer as a guide for where to place the shellac.

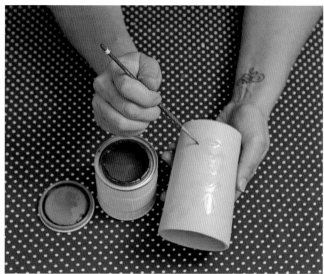

**2.** Apply a layer of well-mixed shellac with a small brush to to the surface of your leather-hard clay, staying within the lines of the transfer. Keep in mind that wherever you apply shellac, you will have a raised texture.

# TROUBLESHOOTING

Sometimes if you wipe your piece too much, the shellac will start to rub off. Ease up when wiping and use a bit more water and less pressure. This will help keep the shellac intact. Sometimes the shellac isn't completely dry before you wipe, even though it feels dry. This can be because the shellac wasn't mixed well or you had a bit of denatured alcohol on your brush before dipping it into the shellac. So start with a clean, dry brush and allow the shellac plenty of time to dry before you start wiping. This drying time varies depending on how wet your piece was to start and the climate in which you are working, but generally 10 to 15 minutes is plenty of time.

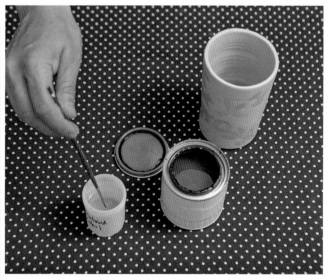

**3.** Allow the shellac to dry until it is no longer sticky to the touch. As you wait, wash your brush in denatured alcohol immediately or soak the bristles in denatured alcohol so it won't be ruined.

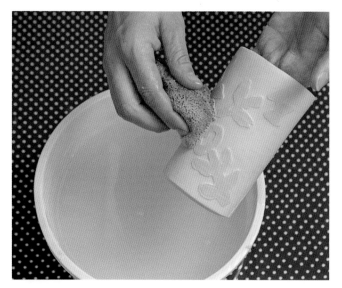

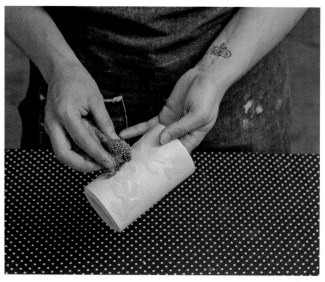

**4.** Once the shellac is dry to the touch, use a well-saturated sponge to wipe the surface of the clay. Because you are using such a wet sponge, there are likely going to be a lot of drips. Wipe your piece over your water bucket to save on cleanup time later!

**5.** Keep wiping until there is a raised texture on the clay surface, but be careful not to overwipe and remove the shellac. After trying the technique a couple of times, you will get a better sense of the limits of the shellac. Dry and bisque fire the form before finishing with a clear glaze.

# TRY IT!

Before you transfer the image onto the leather-hard ceramic surface in step 1, add a few coats of slip or underglaze to the surface and then transfer the pattern on top of the color. Go through the same steps outlined in the project, and when you wipe the surface of the piece, the shellac will hold the color in place and you will get a look similar to sgraffito, only without the carving! This can be a great way to lay out larger areas of decoration, and then you can go back later to add details to the surface. Try drawing through the shellac to add line work to your image.

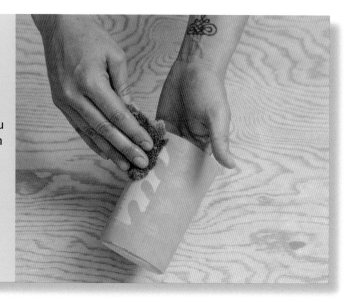

# ARTIST INSPIRATION

**Andy Shaw**

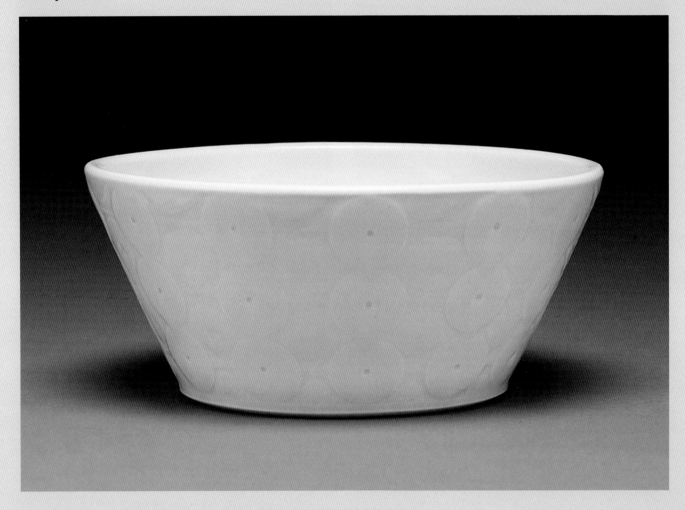

With a BA in history from Kenyon College and an MFA from the New York State College of Ceramics at Alfred University, Andy Shaw has had a long and successful ceramics career. Currently an associate professor at Louisiana State University, Andy produces tableware that has received multiple awards, is shown widely across the United States, and was recently featured in exhibitions in Australia and Korea. Many national and international museums hold his work in their collections. Andy has taught workshops across the country and most recently was awarded the McKnight Residency at the Northern Clay Center in Minneapolis.

**Andy states:** "I create the compositions on my ceramic surfaces by brushing wax resist onto bone-dry porcelain and then lightly scrubbing that surface with a wet sponge. The water of the sponge dissolves the exposed porcelain, and the sponge then removes the dissolved particles. The result is a very light etched surface that the celadon glaze fills in with highlights of blue-green in the carved areas, giving a soft, sugary character to the raised design. The work in this series is made entirely from porcelain and one glaze in the celadon family."

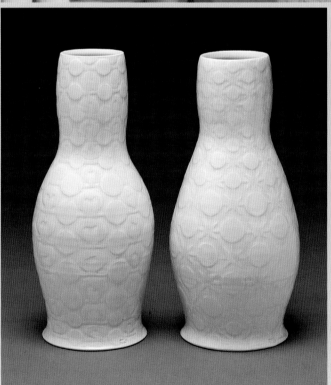

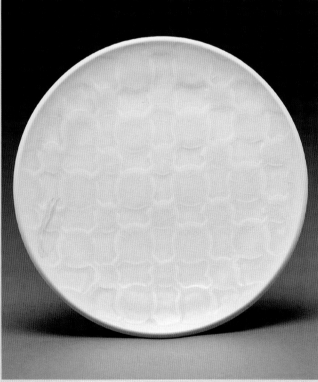

# 6

# SHAPE

||||||||||||||||||||||||||||||||||||||||||||||||||||||||||||||||||||||||||||||||||||||||

In drawing and painting and other two-dimensional artistic mediums, the use of negative space and positive space is a basic design tool that can help define and activate an image and, in this case, an object. Using techniques from color blocking to stenciling, you can work your ceramic surfaces using large or small shapes to create surface patterns and even narratives. In this chapter, we will employ several techniques to create large fields of color using color-blocking techniques, use newsprint to make a resist for greenware, and consider how to use shapes to help define and engage the ceramic surface. Layering one shape over another can create beautiful and complex patterned surfaces akin to a textile. Paper and sticker resists can give delicate silhouettes to basic outlines. Sgraffito, one of the more versatile techniques covered in this book, can range from a large shape to a delicate line. As with the other projects in the book, I suggest combining the following shape projects with projects from the other chapters to develop a layered depth in your ceramic surfaces.

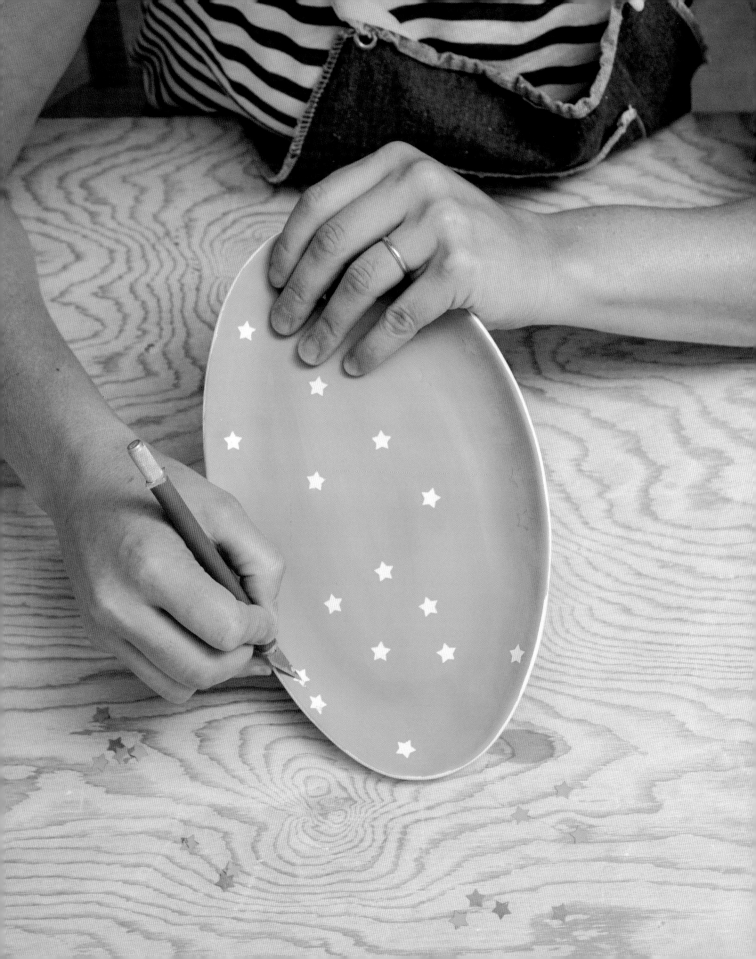

# STICKER RESIST

I started using round pricing stickers in different sizes as resists on the surface of my bisqueware to make perfect polka dots. Because I am a production potter, this was both a time-saving effort and a straightforward way to get perfect dots. Everyone enjoys a good polka dot! This process is fun to do with any stickers you find. With the recent scrapbook home die-cutting printer technology, you can even design and print your own stickers at home quite reasonably.

## Tools

- damp sponge
- bisque ceramic surface
- high-grit sandpaper (optional)
- found stickers
- 1" (2.5 cm) brush
- underglaze
- pen-style craft knife or spear-tipped sgraffito tool
- dust mask
- clear or tinted glaze

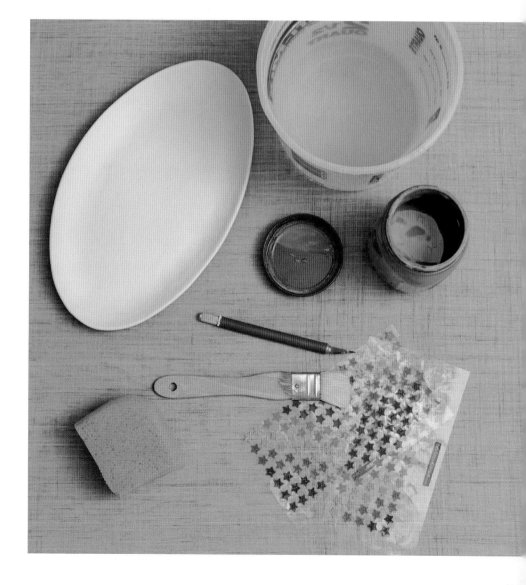

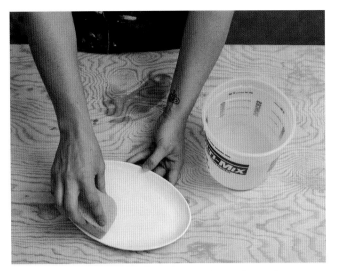

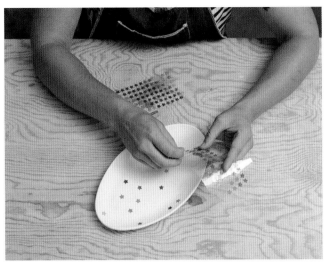

**1.** Use a damp sponge to wipe the surface of your bisque ceramic surface clean of any dust. If your surface has ridges from throwing, sand the ridges with a high-grit sandpaper to keep underglaze from seeping underneath your sticker, which makes for extra cleanup later.

**2.** Apply your stickers to the surface of your bisque piece wherever you'd like the surface to retain the color of the clay. The sticker will act to resist the underglaze you apply over it. Play and explore, cutting your own stickers and creating new forms from found stickers.

# TIP

This works with every kind of sticker I have tried, from glossy clear plastic dots to glittery stickers my daughter has set aside for me to use. Some stickers leave behind a residue on the bisque surface. This can affect the glaze you apply over the surface of your piece after you have removed the stickers. Simply dab a small amount of clear glaze over the areas affected with residue and gently "massage" the glaze to help seal the surface. Works every time!

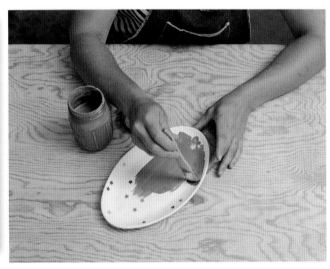

**3.** Once you have created your sticker collage or pattern, use a 1" (2.5 cm) brush to paint one to three coats of underglaze over the surface of the bisque. Allow the underglaze to dry, even over the stickers; this will help you remove the stickers cleanly.

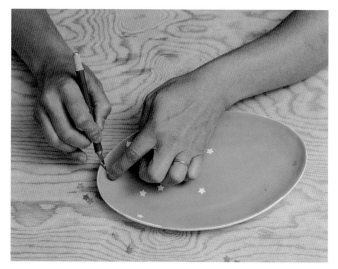

**4.** Gently remove the stickers using your pen-style craft knife or a spear-tipped sgraffito tool by piercing each sticker and lifting with the tool. *Voilà!* If you try to remove the stickers with your fingers, it tends to smear the underglaze and leave behind a line that isn't as clean.

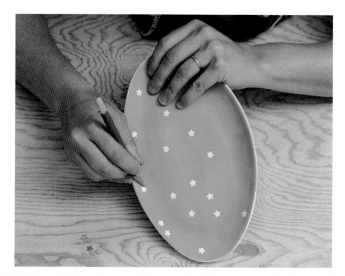

**5.** Usually there is a small amount of cleanup needed around some of the edges, where the stickers might not have been sealed to the bisque surface before applying the underglaze. Simply use a craft knife or spear-tipped sgraffito tool to gently scrape the unwanted underglaze from the surface. This creates dust, so wear a dust mask or work under ventilation.

**6.** Finish your sticker resist surface with a clear or tinted glaze and fire.

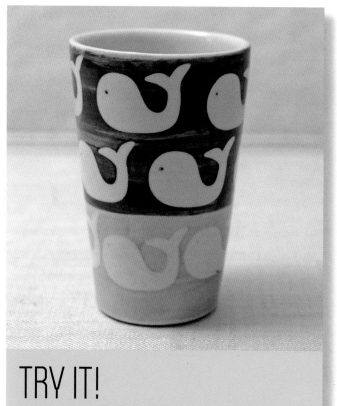

# TRY IT!

Stickers work well with color blocking. While the stickers are adhered to the surface, apply one underglaze color to a section of your piece, and then once the surface is dry, apply a second underglaze color to another section of your piece. Remove all the stickers once the underglaze has dried, and you will have a two-toned surface. The results are lovely!

# ARTIST INSPIRATION

## Heather Mae Erickson

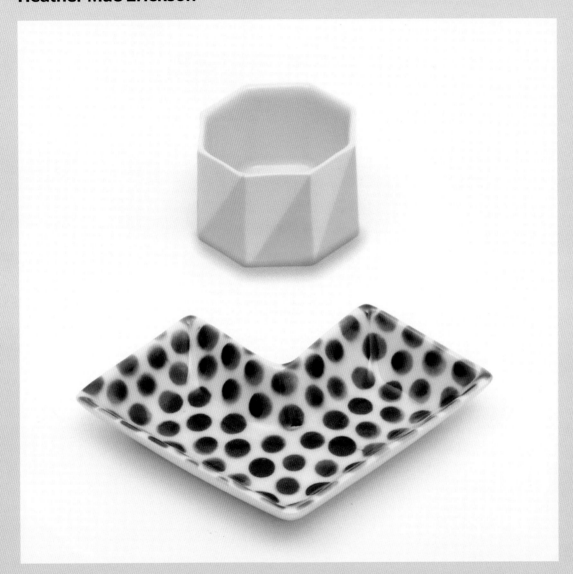

Heather Mae Erickson is an artist, a craftsperson, and a designer. She earned her MFA in ceramic art at the Cranbrook Academy of Art. Heather was awarded a Fulbright fellowship to conduct independent research at Aalto University in Helsinki. Her work has been shown internationally and is represented in collections around the world. She has earned numerous awards, including first place for the Horizon Award presented by the Museum of Art and Design in New York. An assistant professor of ceramics at Western Carolina University in Cullowhee, Heather resides in Sylva, North Carolina.

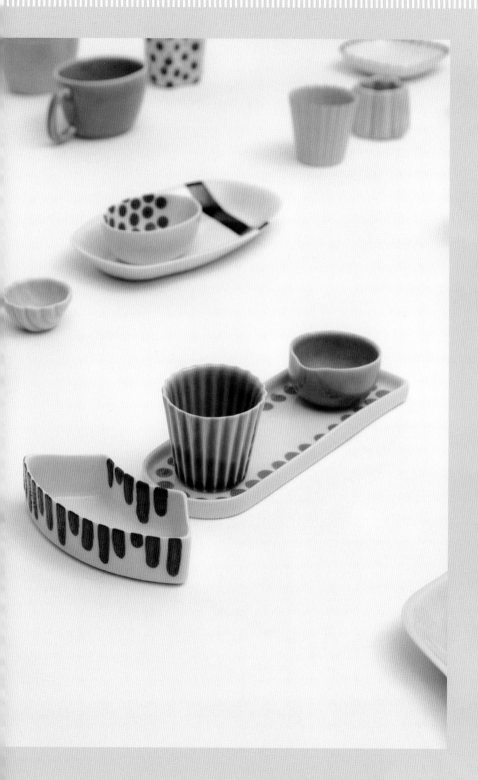

**Heather states:** "I use multiple types of clays, firing methods, and surface decoration application, which lends to more variety of candy-coated colored objects. I use hand-cut or die-cut paper resists on greenware, sponging on greenware and bisqueware, stickers for the outlines of shapes on bisqueware, and different widths of vinyl tapes on greenware. I enjoy the variety of processes as a means to discuss the differences in the craftsmanship of the marks of surface decoration. I am pleased when people think something looks perfect at a distance but when viewed up close they see variation in a dot or a pattern. Underglazes and mason stains in glazes and casting slip give most of the color in the patterned or solid color work."

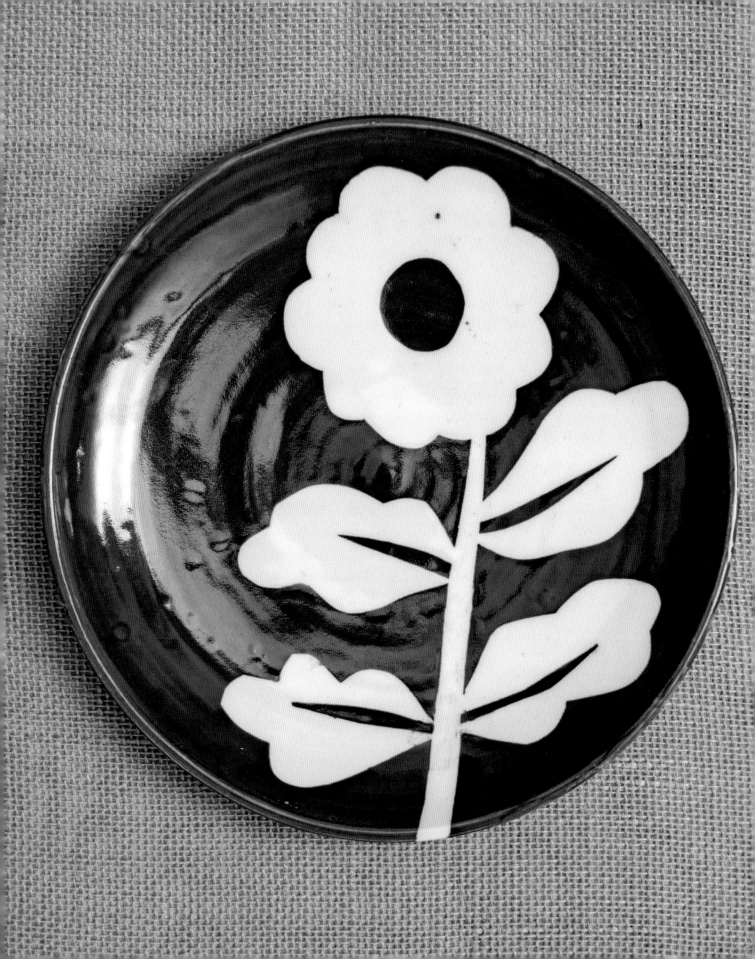

# CONTACT PAPER STENCIL

I first tried this technique when I had accidentally ordered an enormous roll of black contact paper for doing a wall stencil project. It is a great way to get large, controlled areas of color onto the surface of bisque. When I was growing up, my mother always stenciled the walls in our home rather than decorating with wallpaper. This process is akin to printmaking because you can layer stencils on clay the same way you might on a wall or on paper. You can be as complex or as simple in how you approach color blocking a surface using a stencil. Take the form into consideration. This might be a great way to accent shapes that already exist in your form or to create a trompe l'oeil illusion.

## Tools

bisque ceramic surface

damp sponge

source image or laminated tracing transfer (page 53) from template (page 148)

scissors

contact paper

self-healing mat

masking tape

pen-style craft knife with a fresh blade

1" (2.5 cm) brush

underglaze

clear or tinted glaze

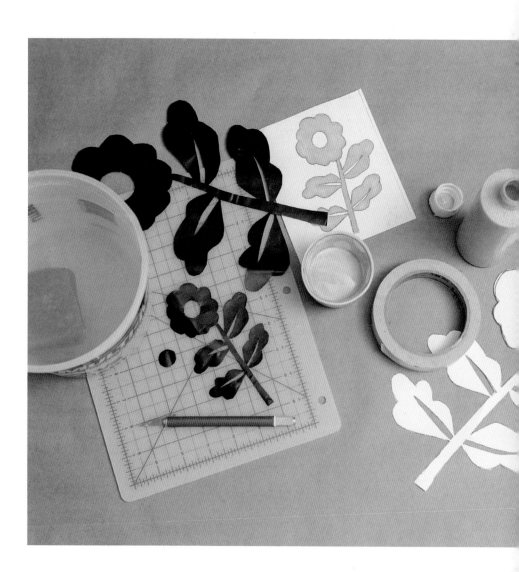

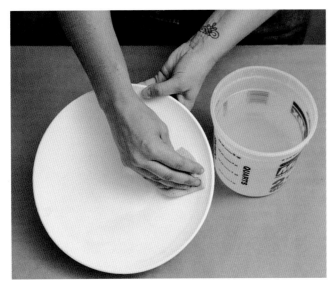

**1.** Wipe your bisque ceramic surface clean with a damp sponge to remove dust. Set aside.

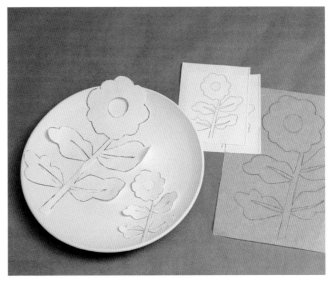

**2.** Choose your stencil imagery while keeping the scale of your piece in mind. Make a drawing or photocopy of the stencil imagery before cutting the stencil to make sure the scale is correct. Enlarge or reduce as needed. If you want to repeat a pattern, cut more stencils from the image, and consider making copies of your source image.

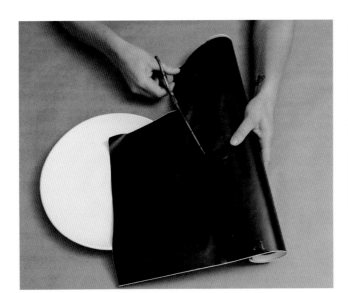

**3.** Cut a piece of contact paper large enough to create your stencil and place it on your self-healing mat.

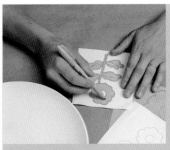

# TIP

It can be helpful to color in the area of your drawing or source imagery that you plan to cut out. This gives you an idea of how your final image will look and provides a strong guideline for where to cut and where not to cut.

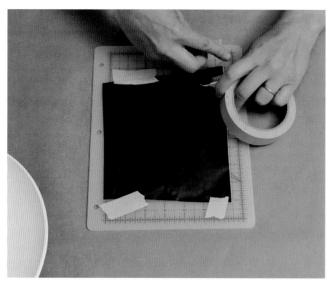

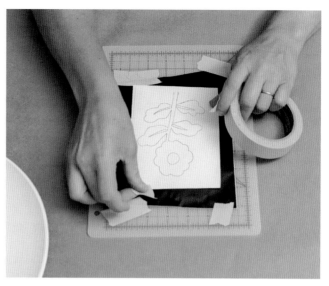

**4.** Use masking tape to secure your contact paper to your self-healing mat.

**5.** Place your source image over the contact paper. Adhere the source image to the contact paper using masking tape.

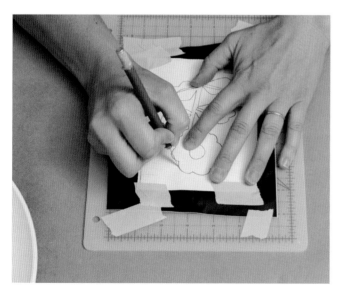

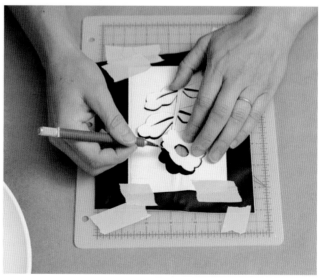

**6.** Using your pen-style craft knife with a fresh blade, cut out your stencil, cutting through the source image and the contact paper to the self-healing mat.

**7.** Set aside the cutout sections and remove the remainder of the source image from the contact paper.

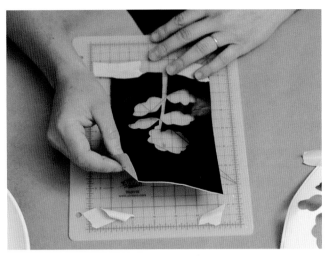

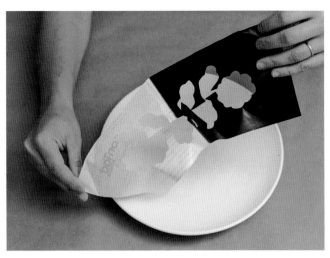

**8.** Remove the contact paper from the self-healing mat and trim any excess contact paper if necessary.

**9.** Peel the backing off the contact paper and arrange it as desired on your bisque ceramic surface.

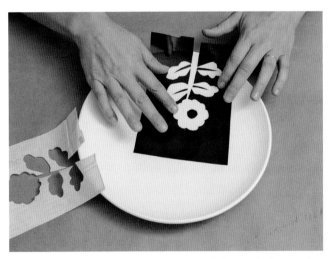

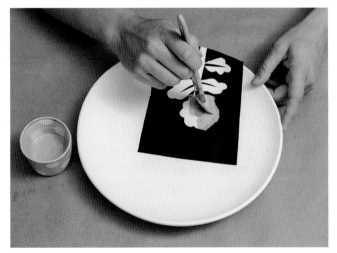

**10.** Run your fingers over the edges of the stencil to make sure the contact paper is adhered to the bisque surface.

**11.** Apply one to three coats of underglaze to the surface of the bisque. The contact paper will resist the underglaze.

# TRY IT!

Use the contact paper you cut out to create your stencil as a sticker using the sticker resist technique outlined on Project 9, page 111. Use contact paper to create your own stickers, using everything from found imagery to your own drawings!

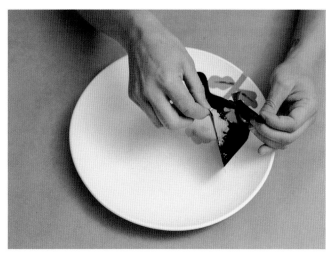

**12.** Let dry, and gently remove the stencil, revealing your large area of stencil underneath!

# TRY IT!

Use a pin tool or stylus to scrape back to the bisque surface of the color that you added. This will give you a line drawn in the color of your clay body. A delicate line in contrast to the large field of color can be a great way to activate your ceramic surface, and the variation in surface treatment adds points of interest to your piece.

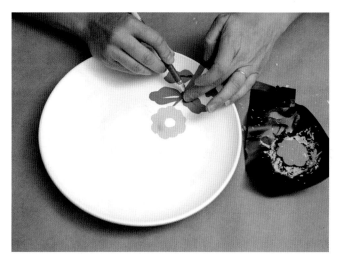

**13.** Using the tip of a craft knife, gently scrape away unwanted areas where the underglaze might have seeped beneath the contact paper.

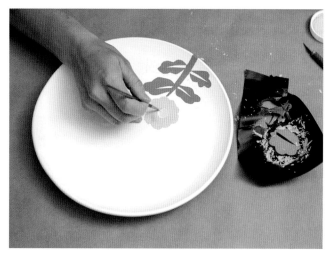

**14.** Using additional colors of underglaze, try painting in areas that were resisted with the contact paper, such as the center of the flower, as shown here. Finish with a clear or tinted glaze and fire.

# ARTIST INSPIRATION

## Heather Braun-Dahl

Heather Braun-Dahl is a full-time studio potter and painter from Vancouver. She graduated with a BFA in ceramics and painting from the Emily Carr University of Art + Design, and then went traveling, started a family, taught art classes to kids, and dreamed about becoming a full-time artist. In 2007, she brought her love of painting and ceramics together under one roof and called it Dahlhaus. Combining modern, Scandinavian, and vintage-inspired designs, the patterns for her pots are frequently based on abstract paintings from her art school days. In the past few years, her work has been picked up by major retailers such as Anthropologie and West Elm, and sold in galleries such as Clay Studio and Gardiner Museum and in numerous smaller independent shops across North America. Her bold, graphic designs, patterns, and color sensibility have captured the attention of bloggers, magazines, and clients all over the globe.

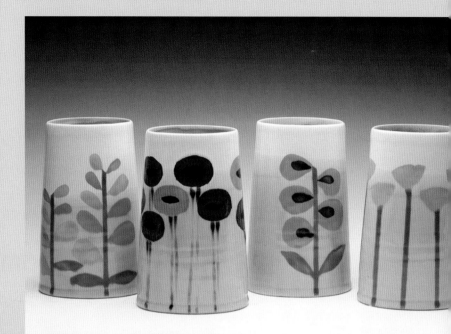

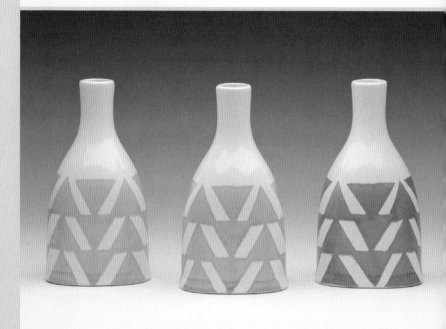

**Heather states:** "I started using green tape to cut smaller shapes and then looked into a low-tack contact paper for cutting out shapes as a way to mask off a pattern on a bisqued pot before glazing it. This method of glazing takes a few days, because each step requires a clean sponge and then drying time before the next step can be performed. This method isn't great for fine lines or if you have a lot of texture on a bisqued surface. Once the pot is bisqued, I glaze the inside before individually cutting the stencils out of masking tape or low-tack contact paper. I usually think of my designs as 'growing up' from the bottom of the pot, so I often reference flowers, leaves, and stripes. The 'background' glaze is dipped and then a layer of wax is applied and left to dry before being peeled off, revealing the pattern as unglazed. Once the area has been cleaned up, I paint the bright glazes or dip the pot into a different glaze to fill in all the unglazed designs, then I clean up any extra drips that might be on the waxed area before firing. I love the soft, clean edge where the different glazes meet."

# PAPER RESIST

It seems like I see the paper resist technique more than ever—and for good reason! Using newspaper as a resist is an accessible and functional method for surface decoration on greenware. It works with any clay body and can even be used for layering glazes on bisque. This is an effective method for layering imagery on greenware using multiple colors of opaque slip over each other. Layers of newspaper can be cut at the same time, making it easy to cut multiples for repeating patterns and motifs. Paper resist lends itself well to being used in combination with other techniques applied to bisque.

## Tools

source image or laminated tracing transfer (page 53) from template (page 148)

photocopier (optional)

newspaper or newsprint

scissors or craft knife

self-healing mat

1" (2.5 cm) brush

slip or underglaze in two colors, one darker and one lighter

leather-hard ceramic surface

craft knife or pin tool

clear glaze

**1.** Scale your source image motif or template to fit the piece to which you are applying it. If you have drawn the image yourself, simply redraw the image to scale. If you are using a sourced image, a photocopier can be a quick and easy way to adjust the image size.

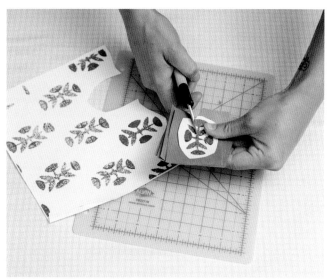

**2.** Place one sheet of newspaper beneath the source image for one paper resist, or stack several layers of paper beneath to create multiples. Using your scissors or craft knife on a self-healing mat, cut out the paper using your source image as a guide. Set aside.

**3.** Using a 1" (2.5 cm) brush, apply one or two coats of the slip or underglaze color of your choice to the surface of your greenware.

**4.** Let the slip dry enough so that you can touch the surface and it will hold up. You'll know it is dry enough when the sheen is no longer on the surface. It does not need to dry back to leather-hard.

**5.** Gently place your paper cutouts onto the surface of the colored slip or underglaze.

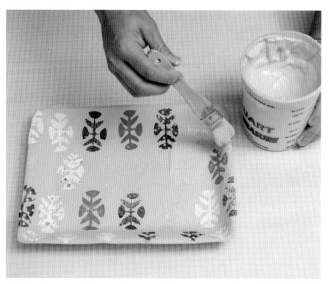

**6.** Apply an additional coat of the same colored slip or underglaze over the paper.

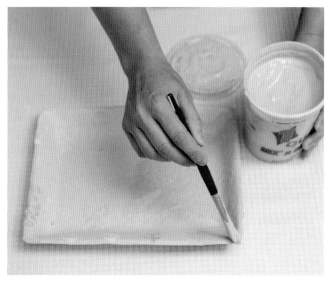

**7.** Once these layers have dried back to a leather-hard state, apply a top coat color. Apply two or three coats over the base color to ensure a solid layer of color.

# TIP

When using underglazes and slips in ceramics, apply lighter colors first, and then darker colors over the top. Using darker colors as layered decoration over lighter colors will typically give you the best color results.

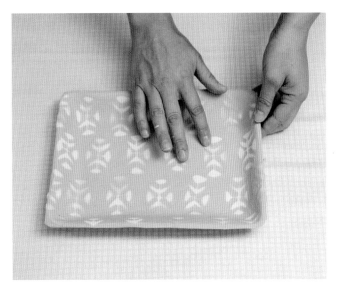

## TIP

Your piece has dried for too long if the edges are jagged where you peel up the paper. Try spritzing the surface of the piece with water to rehydrate the surface before peeling up the paper.

**8.** Allow the slip or underglaze to dry again—back to a leather-hard state, or until you can touch the surface and it doesn't stick to your finger.

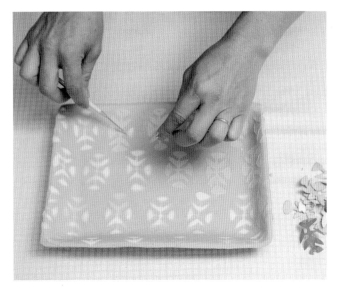

**9.** Using the tip of a craft knife or a pin tool, gently remove the paper from the piece, revealing the layer of color beneath.

**10.** Dry, bisque, and apply a clear glaze.

# TRY IT!

This technique is perfect for greenware, but try using this layering method with glaze. Place paper cutouts over a fresh layer of glaze. You may need to dampen the paper with a spray bottle to keep the cutouts in place. Carefully use a brush to layer another glaze color over the top. Once the glaze is dry, gently remove the paper from the piece to reveal two-toned glazes. Fire and admire the lovely results!

# ARTIST INSPIRATION

## Meredith Host

Meredith Host was born and raised in Detroit. She received her BFA in ceramics from Kansas City Art Institute and her MFA in ceramics from Ohio State University. Meredith has done numerous ceramic residencies, including the School for American Crafts at RIT in Rochester, New York; Watershed Center for the Ceramic Arts in Newcastle, Maine; and Dresdner Porzellan Manufactory in Dresden, Germany. She was named a 2011 Emerging Artist for NCECA and *Ceramics Monthly*. Meredith lives in Kansas City, Missouri, and she is a full-time studio potter. She has an extensive collection of patterned kneesocks and taxidermy shoulder mounts and is a self-proclaimed horror dork and root beer connoisseur.

**Meredith states:** "My surfaces are decorated with multiple layers of brightly colored paper, stenciled and screen-printed underglazes, and china paint decals. My dot patterns are based on my collection of 'overlooked domestic patterns' (toilet paper and paper towel patterns). I play around with asymmetry in color and pattern to create dynamic surfaces. On my paper stencil layers, I use craft punches and a paper cutter to make the stencils, and I enjoy the crisp lines that the stencils provide. The screen-printed patterns shift both under and over the stenciled fields of solid underglaze color."

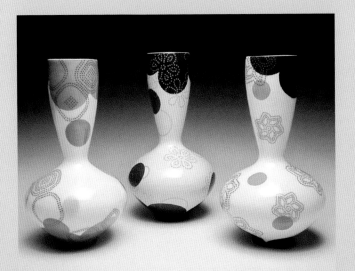

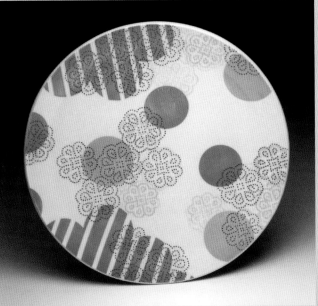

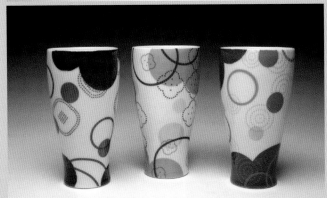

# ARTIST INSPIRATION

## Adero Willard

Adero Willard lives in Western Massachusetts where she is a studio potter and an instructor of ceramics at Holyoke Community College. Adero received her BFA at Alfred University and her MFA at Nova Scotia College of Art and Design. She completed a year-long residency at the Watershed Center for Ceramic Arts in Maine, where she was the Salad Days Artist. Adero shows her work in galleries and craft shows nationally, including Ferrin Gallery, Craft Boston, and the Smithsonian Craft Show. She teaches workshops at universities and art centers throughout the United States, and her work is featured in a number of publications and books on ceramics. Her lifelong interest in surface decoration is fueled by a passion for textile design, painting, and collage.

**Adero states:** "I am intrigued with decorative surfaces. Combining layered pattern, sgraffito, and color along with a wax-resist technique, I create surfaces where some parts are hidden, some are revealed, and some are seen under the veil of a layer. My favorite forms to decorate are platters or forms that are oval or square because I enjoy creating compositions that dissect a flat space, transition from front to back, or move around a corner. My love for quilts and appliqué feed me artistically, but mass production has been the catalyst for why I am inexorably pulled toward the one-of-a-kind. All my designs are done directly on leather-hard clay forms, and they are rooted in a love of nature, narratives from my ancestry, and my imagination."

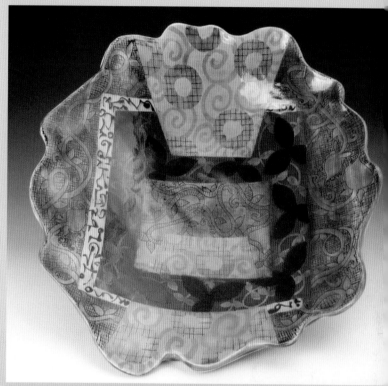

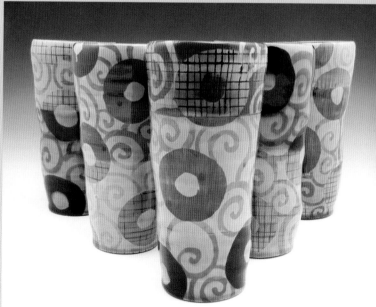

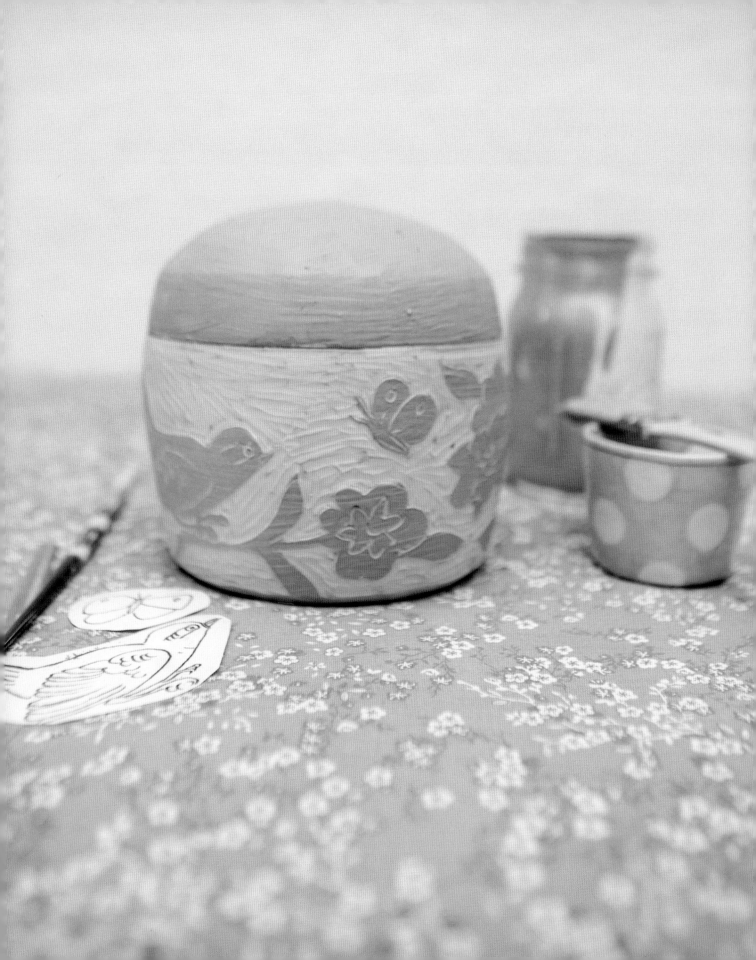

# SGRAFFITO

The sgraffito technique was introduced to me in college by my professor at the time—artist Kathy King. When Kathy saw that I was making pots, drawings, and woodcuts, she urged me to try sgraffito as a way to combine the mediums. I was immediately besotted with clay and have been ever since. The act of carving an image out of clay is meditative in the same way that drawing and painting can be, and the imagery is graphic and indicative of the sgraffito technique. This technique can be done freehand, but you can also use templates to draw anything you like on the surface of your clay. My favorite aspect of sgraffito is not having to worry about which glaze to put over my work. Clear is enough! After working as a production potter for a commercial studio that used sgraffito to decorate their wares, I have come to love a few special tools for this technique that I am excited to share with you.

## Tools

two 1" (2.5 cm) brushes

slip or underglaze

leather-hard ceramic surface

source image or laminated tracing transfer (page 53) from template (page 149)

stylus or African porcupine quill

spear-tipped sgraffito tool or bamboo carving tool

green scrubbing pad

clear glaze

**1.** Using a 1" (2.5 cm) brush, brush two or three layers of slip or underglaze on your leather-hard ceramic surface. You'll see fewer brushstrokes, which can result from applying only one layer of color. Allow to dry to a leather-hard state.

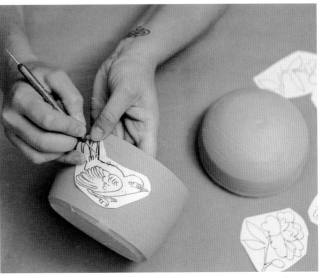

**2.** Use your template to transfer your imagery to the surface of the piece. (See page 53 for how to make a template.)

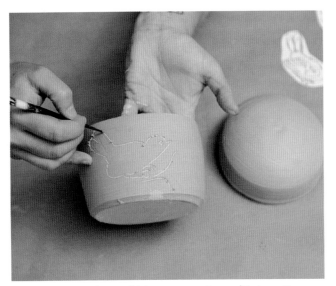

**3.** With your stylus or African porcupine quill, draw the outline of the image that you'd like to leave the color of the slip. (You will carve up to this line.)

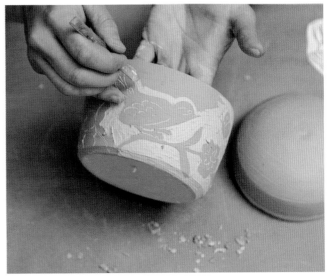

**4.** Once you have drawn your outlines, begin carving into the piece using your spear-tipped sgraffito tool or bamboo carving tool.

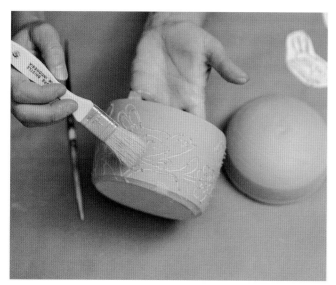

**5.** Use a dry, clean 1" (2.5 cm) brush to clear any carving crumbs so you can see as you carve. This technique can create a lot of dust if your carvings fall to the floor, so take appropriate measures. Allow the clay to dry to bone dry.

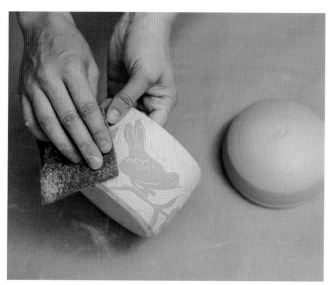

**6.** Before putting the work into bisque, lightly sand using a green scrubbing pad to remove any burrs that will be sharp to the touch after firing. The underglaze will hold up in sanding, but be mindful and sand gently. Bisque fire and finish with a clear glaze.

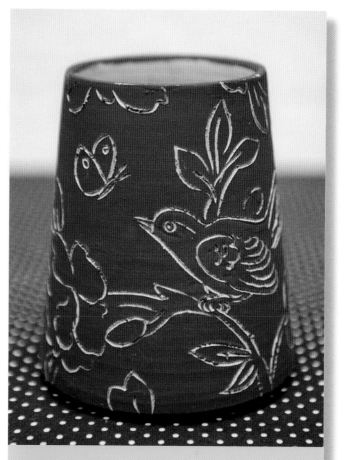

# TRY IT!

This technique works well if you simply apply two or three coats of underglaze or slip to the surface of your piece and then use your stylus or quill to draw through back to the clay body without carving out any of the negative space. Depending on the image or the clay body, the line can be very striking or subtle. Many ceramic artists working with earthenware use sgraffito in this way, especially when using a white or light-colored slip or underglaze over the red clay. The lines remain the dark red of the clay body.

# MAKE A BAMBOO TOOL

It's easy to make your own bamboo tool, and with its wonderful, flat surface, carving out large areas is a piece of cake. Finding bamboo is the only major challenge. Try friends who have it growing in their yards or check with your local florist.

## Tools

small handsaw

bamboo piece

craft knife or saw

200-grit sandpaper

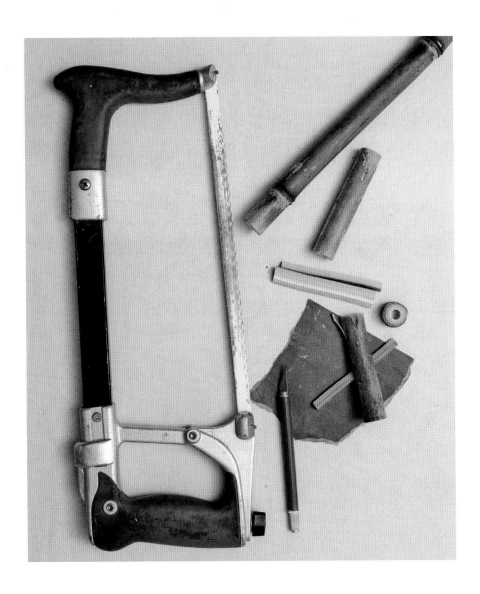

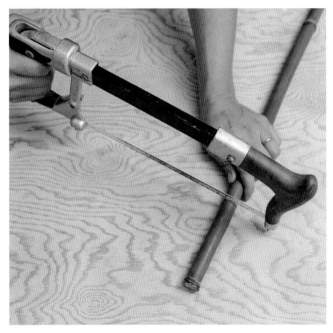

**1.** With a small hand saw, cut the bamboo to the desired length.

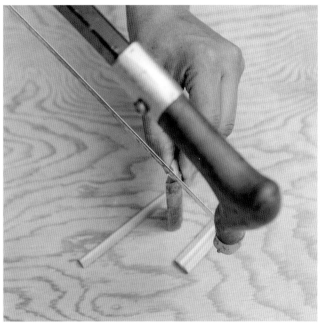

**2.** Using a craft knife or saw, rip a strip lengthwise off of the bamboo section to create a long, narrow strip.

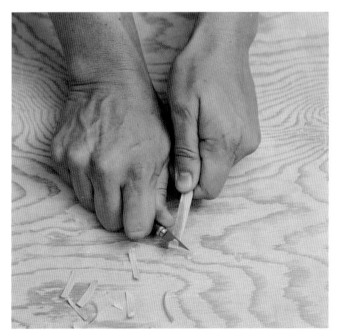

**3.** Sharpen the tip of one or both ends of the piece, keeping it flat. Adjust the sharpness and tip as desired.

**4.** Gently sand the tip to create a smoother carved line.

# ARTIST INSPIRATION

## Kari Radasch

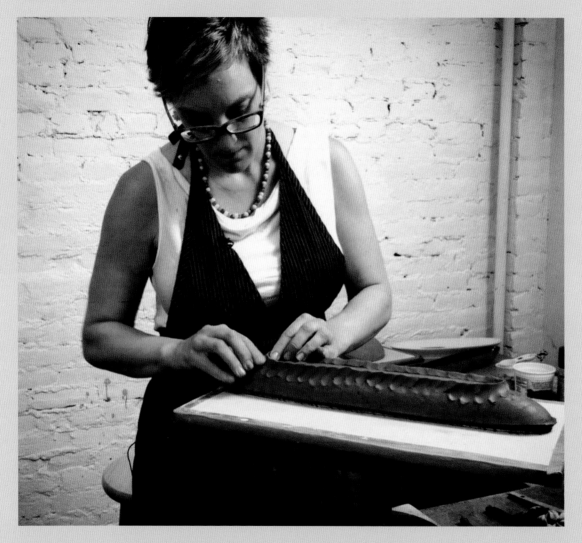

Kari Radasch is a studio potter living in Westbrook, Maine. She received her BFA from Maine College of Art and her MFA from the University of Nebraska Lincoln. Kari was the first potter to receive the Evelyn Shapiro Foundation Fellowship at the Clay Studio in Philadelphia, and she was awarded an SAC Artist Award from the Society of Arts and Crafts in Boston. A demonstrating artist at the 2010 NCECA conference in Philadelphia, she has taught workshops and lectured across the country. Currently, Kari teaches ceramics at Maine College of Art, and she can be found pushing a double stroller around southern Maine or potting at her home studio.

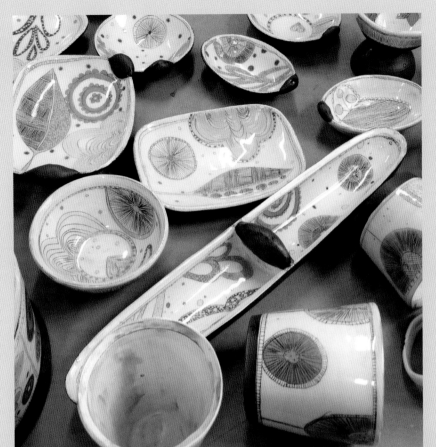

**Kari states:** "I work very intuitively. When I am in a decorating phase, I start by scattering source material around my work area. This typically includes children's books, folk art reproductions, textile designs, and snapshots of inspirational visuals. I have assembled a large vocabulary of imagery that I work with and am constantly adding to. The first step begins with an even coat of white terra sigilata. I then draw into the surface of the clay. I fill in the drawing with colored sig, trying not to fill in the delicate lines I have just incised. After bisque, I paint the entire surface with a black underglaze and then wipe it off. This gives the ceramic surface a patina and an 'antiqued' look. I add a few colorful glaze accents. A final clear glaze goes over the entire pot."

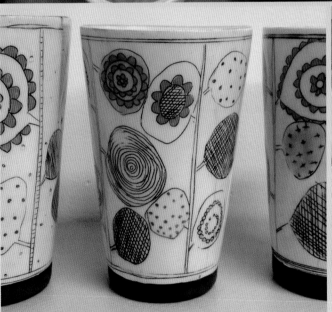

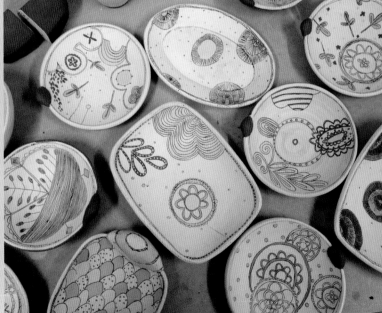

# ARTIST INSPIRATION
## Maria Dondero

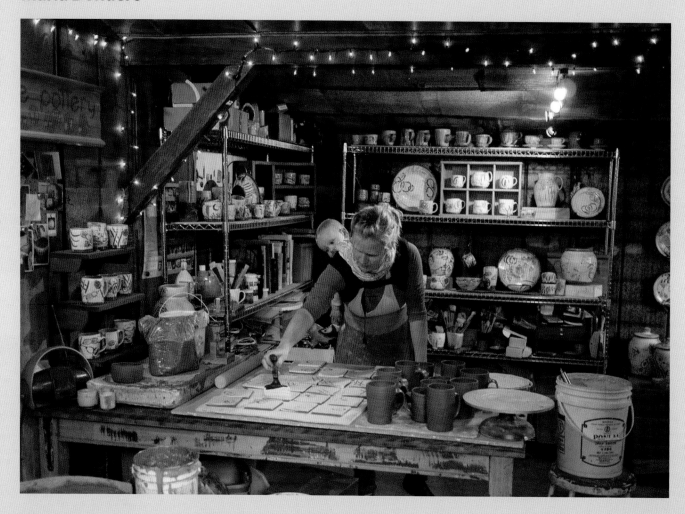

Maria Dondero makes pots and teaches in Athens, Georgia, where she lives
with her husband and twin boys. She received her MFA from the University of
Georgia in 2008 and has worked as a studio potter and adjunct professor ever
since. Maria makes functional pots with an aesthetic that draws on the history
of ceramics. While subtly referencing pottery traditions from around the world,
Maria intuitively sketches images on her ceramic surfaces from her surround-
ings. Her work is exhibited in galleries throughout the United States.

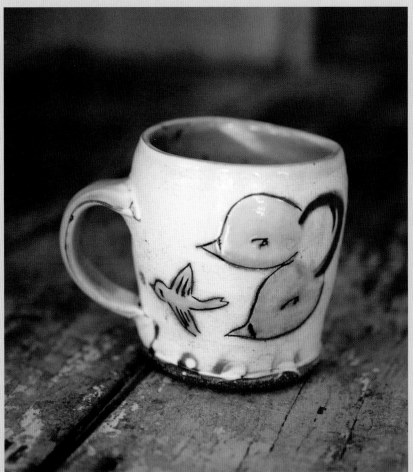

**Maria states:** "When the piece is leather-hard, I apply a white kaolin slip either by dipping or brushing. After the slip dries a bit, I sketch quick drawings into the clay, revealing the dark clay underneath. I try not to think too much about what I am drawing; rather, I let the random finger swipes and the shape of the pot suggest silly images of plants and animals to me. After the bisque firing, I stain the sgraffito lines with an iron/copper stain to add another layer of texture and color. Next, I add colors—primarily a hand-mixed glaze with copper and iron oxides that I like for the vibrancy of hue and the contrast that it adds to the dark clay and white slip. Last, I use an atomizer to spray a light clear glaze over the pieces, leaving them with lots of texture and not too shiny."

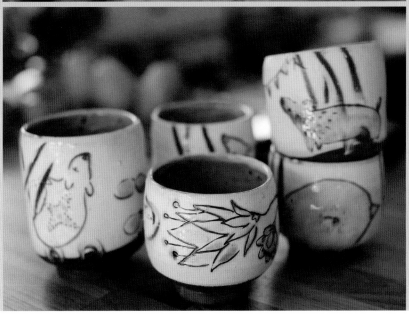

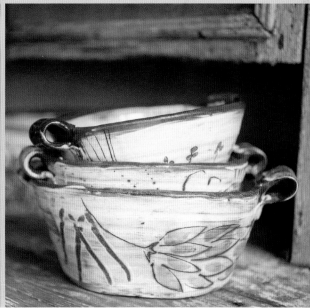

# TEMPLATES

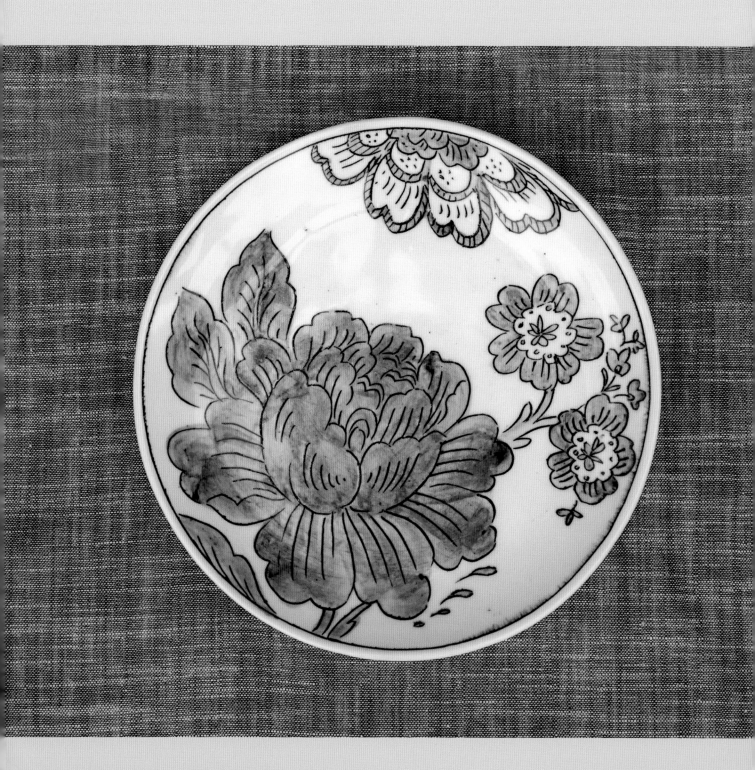

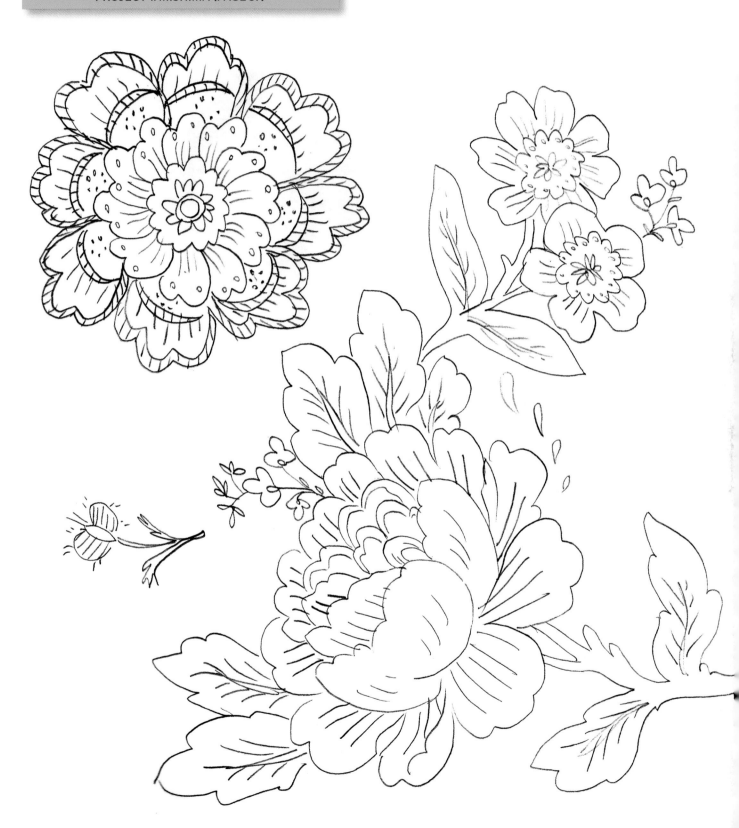

TRIANGLE DOT STAMP TEMPLATE

TRIANGLE STAMP TEMPLATE

TRIANGLE LINE STAMP TEMPLATE

Use the word prompts below for inspiration or create your own chart of prompts.

| fly | light | round | bubbly | dream |
|------|---------|------|--------|-------|
| swirl | scallop | loop | burst | petal |
| dots | windy | root | leaf | open |
| dense | dash | pop | star | stern |
| lace | link | ferry | pop | grow |

**PROJECT 10: CONTACT PAPER STENCIL (PAGE 117)**

**PROJECT 11: PAPER RESIST (PAGE 125)**

# RESOURCES

## Clay

The clay body used to illustrate the projects in this book is Laguna's Miller WC-617 #16. This clay is a Grolleg cone 6 porcelain, making it off-white, more plastic, and generally forgiving. Additional silica reduces crazing in my favorite glaze.

Many of the companies listed here provide more supplies than just clay—visit their sites for their full list of products.

### North America
Laguna (United States)
www.lagunaclay.com

Tucker's Pottery Supply (Canada)
www.tuckerspottery.com/tkps/

### European Union
Potclays Limited (England)
www.potclays.co.uk

Alisdair Kettles Pottery Supplies (Scotland)
www.alisdairkettlespotterysupplies.com

Ceradel (France)
www.ceradel.fr

Colpaert-Van Leemputten (Belgium)
www.colpaertonline.be

### Australia
Clayworks Australia
www.clayworksaustralia.com

## Underglaze, Underglaze Pencils, and Glaze

Although there are slip and engobes in my recipe section, there is nothing like the versatility of a commercial underglaze. Underglaze can be added to greenware and bisqueware and fires well in a wide range of firing temperatures. AMACO underglazes are used for the majority of projects in this book.

My favorite glazes also interact well with the AMACO underglazes. The Kitten's Clear glaze that I mix in my studio and use to finish the illustrated projects in this book is in the Recipes section on page 153. If you aren't able to mix your own glazes, the following companies are great resources.

### North America
AMACO (United States)
Underglaze pencils are used to doodle on the surface of bisqueware in project 4. AMACO underglaze pencils come in many colors and fire well in a wide range of temperatures.
www.amaco.com

**The Ceramic Shop** (United States)
The tinted glazes in this book were all Ceramic Shop Cone 6 Casual Tints. Fantastic consistent results when dipping or brushing and no crazing on the Miller #16 clay body from Laguna.
www.theceramicshop.com

**Spectrum USA** (United States)
www.spectrumglazes.com

**Ceramic Services** (Canada)
ceramicservices.com

**Spectrum Glazes** (Canada)
www.spectrumglazes.com

**European Union**
Scarva Pottery Supplies
(Northern Ireland)
www.scarva.com

**Cerama High Temperature Products A/S** (Denmark)
http://cerama.dk

## Ceramic Equipment, Tools, and Supplies

AMACO has a great drawing tool called the T-3 Stylus that I recommend using with the transfer templates as well as mishima and sgraffito techniques. In addition, AMACO is a great resource for most of your tool, material, and general supply needs. (See AMACO on the previous page.)

**North America**
Bailey Ceramic Supply
(United States)
www.baileypottery.com

For Canada, see "Underglaze, Underglaze Pencils, and Glaze."

**European Union**
See the companies listed under "Clay" and "Underglaze, Underglaze Pencils, and Glaze."

**Australia and New Zealand**
Walker Ceramics (Australia)
www.walkerceramics.com.au

Wellington Potters Supplies
(New Zealand)
www.wellingtonpotterssupplies.co.nz

## Pinterest

I use Pinterest mainly to keep inspiration folders, and also to keep a folder of color combinations that I like. I fall back on Pinterest often when I am looking for new design concepts.
www.pinterest.com

## Instagram

Instagram is a good online resource for inspiration, sharing photos, and keeping track of your own inspirations through photography.
instagram.com

## Rubber Stamps

Making your own artwork into custom rubber stamps is now super easy thanks to online custom stamp companies such as Simon's Stamps. Simply upload image files and order stamps individually through the website.
www.simonstamp.com

## Magazines

Magazines have been a wonderful resource for inspiration and are great for keeping on top of what is happening in the world. Some of my favorite magazines, below, are international and worth the extra money.

*Elle Décor* (United States)
www.elledecor.com

*Selvedge* (England)
www.selvedge.org

*The World of Interiors* (England)
www.worldofinteriors.co.uk

*Frankie* (Australia)
www.frankie.com.au

## Embossed Paper Textures

Embossed paper is a great way to add fun surface texture to your clay. Paper Mojo has a great selection. Preserve the paper by coating it with a couple layers of shellac.
www.papermojo.com

## Museum Web Resources

Most major museums now have a partial if not full online listing of their collections. My favorites always help when I need a little inspiration or am looking for historic source material.

**Cooper-Hewitt** (United States)
http://collection.cooperhewitt.org

**Metropolitan Museum of Art**
(United States)
www.metmuseum.org/collection

**New York Public Library**
(United States)
www.nypl.org/collections

**Victoria & Albert Museum**
(England)
http://collections.vam.ac.uk

# RECIPES

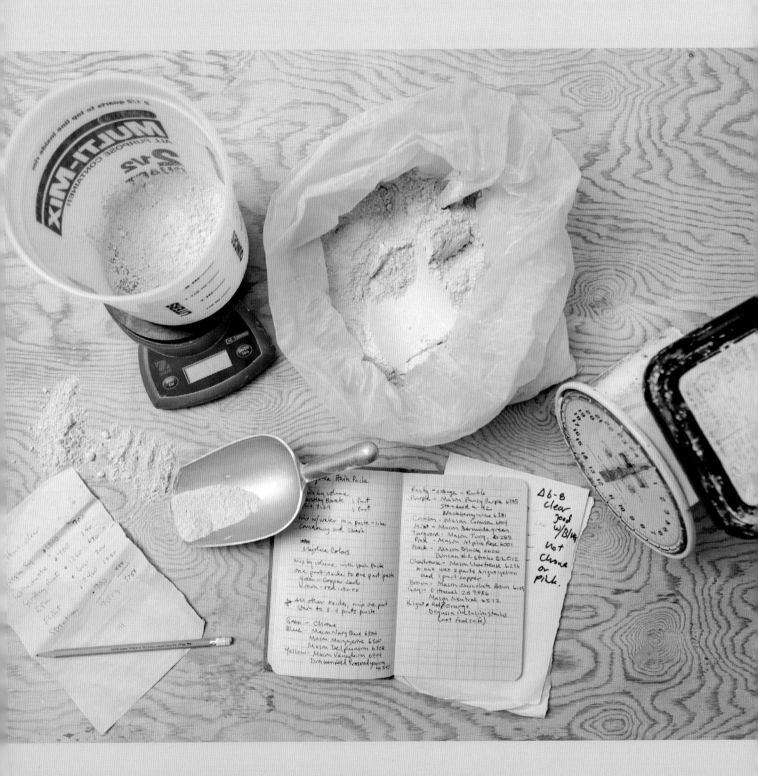

## Cindy Kolodjeski Vitreous Engobe Base: Cone 04 Oxidation

Fires to cone 6, but please test in your studio.

| | |
|---|---|
| EPK | 10 |
| Kentucky Ball #4 | 30 |
| *(I use OM4 Ball Clay just fine)* | |
| Glomax (calcined kaolin) | 50 |
| Frit 3110 | 36 |
| Talc | 30 |
| Silica | 40 |
| CMC (dry) | 2 |
| Macaloid (dry) | 2 |

Mix with water to a pastelike consistency for application to bisqueware. Add stains and oxides to the above base proportionally in equal parts (1:1) by volume. Mix thinner to use as you would use a commercial underglaze.

## Arnie's Fish Sauce Slip: Cone 04–10 Oxidation or Reduction

Versatile slip base. Fits cone 04–10 clay bodies with no problems. Opaque white. Takes added colorants and oxides well to make colored slips.

| | |
|---|---|
| China Clay (Grolleg) | 43.3 |
| Flint | 15.71 |
| Kona F-4 Spar | 23.67 |
| Bentonite | 9.47 |
| Pyrax | 7.85 |

Combine all dry ingredients and mix together. Once mixed, slowly add water to achieve a thick, heavy cream consistency. This slip also works well at a thinner consistency, either brushed on or dipped.

## Kitten's Clear Gloss: Cone 6 Oxidation

| | |
|---|---|
| Neph Sy | 30 |
| Wollastonite | 8 |
| Gerstley Borate | 21 |
| EPK | 10 |
| Flint | 41 |
| Strontium | 15 |

Combine all ingredients and sieve through 80- and then 100-mesh screens. This glaze works best when applied in very thin layers.

Suggested colorant and oxide percentages for Kitten's Clear to make tinted clear glaze colors:

**Bermuda Mason Stain:** 4%

**Yellow Mason Stain:** 4%

**Bright Purple:** 8%

**Cobalt Carbonate:** 1%

**Lobster Red Mason Stain:** 8%

**Coke Bottle Clear Tint:** 0.25% Red Iron Oxide and 0.2% Copper Carbonate

**Robin's Egg Blue:** 0.25% Robin Egg Mason Stain and 0.5% Copper Carbonate

# GLOSSARY

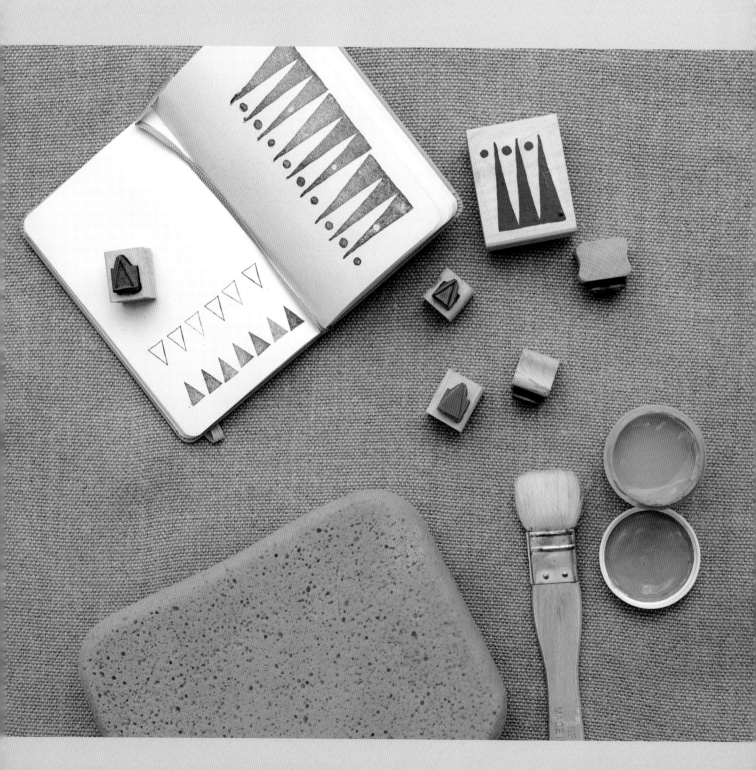

**Bisqueware, bisque:** Ceramic that has been fired once to about 1800°F (982°C). The bisque firing burns off all moisture, making the ceramic water-absorbent, and hardens the clay to allow for easier handling and glaze application.

**Bone dry:** A term used to describe greenware pottery that has dried as much as possible before it has gone through its first firing (bisque firing). When held, bone-dry greenware is no longer not cool to the touch. Coolness indicates that evaporation of moisture in the clay is still taking place. Bone-dry wares are at their most fragile state.

**Calcined:** A kaolin that has been heated until the combined water is removed and the plastic character of the clay is destroyed is considered calcined. The use of calcined kaolin in engobes and underglazes allows them to be applied to the bisque surface because the kaolin will not shrink in the firing process. It has already been fired.

**Ceramic stains:** Stains can be used by themselves as an underglaze color, in slips, in clay bodies, in glazes, painted on glazes, and in overglazes. They typically come in powdered form. Most common are mason stains, commercially made ceramic stains that can be added to a slip or an underglaze base to make it colored. Mason stains add a wider range of colors for ceramic surfaces than more naturally occurring metal oxides, which are also used for coloring the ceramic surface.

**Ceramic wax:** Water-based wax that can be brushed onto the surface of greenware or bisqueware to act as a resist.

**Clay body:** The actual clay mixture, consisting of different types of clay formulated to create a specific look and feel. Materials other than clay may also be included to aid plasticity, lower or raise the clay body's firing temperature, or change the final fired coloration.

**Color blocking:** A method of combining multiple solid colors in a surface. The surface revolves around a palette of two or more colors. Prints and patterns are typically not used in color blocking, because such designs would take away from the "blocked" visual.

**Crazing:** Cracks in a glaze, seen as lines that appear to be across the glaze surface. It occurs as a result of glaze tension, typically from the glaze not fitting the clay body well.

**Deboss:** To depress a decoration or design below the surrounding surface.

**Earthenware:** Non-vitrified ceramic ware with a high iron oxide content that makes the earthenware a reddish color. Bisque fired to a higher temperature (typically cone 04) and glaze fired to a lower temperature (cone 05 to 06).

**Emboss:** To carve, mold, or stamp a design onto a surface so that it stands out in relief.

**Flux:** An element or compound used in clay bodies or glazes that lowers the melt temperature of that clay body or glaze.

**Glaze:** Glaze gives a vitreous surface or coating to fired ceramics, providing a sealed surface that makes ceramics more food-safe and functional. It is most often applied after bisque firing either by brushing or dipping.

**Greenware:** Any clay that is in the unfired state is considered "green" or "greenware."

**Grog:** Clay that has been fired and then ground up to be used in the making of another clay body. Grog can come in many particle sizes, from fine to coarse. It is used to reduce shrinking in clay bodies as they dry and as they fire. Commonly used in clays for handbuilding.

# GLOSSARY (CONT'D)

**Handbuilding:** Working with clay using hands and basic hand tools. The most common methods for handbuilding are pinching, coiling, and slab building.

**High fire:** Firing temperature for clay starting at cone 8 and going as high as cone 13. The standard high-fire range is cone 9 to 10. The majority of more common stoneware and porcelain clays are high fire.

**Laminate:** To cover something (such as paper) with a layer of clear plastic, such as packing tape.

**Leather-hard:** A specific stage during the drying of clay. At this stage, clay is still visibly damp, but it has dried enough to be able to be handled without deformation. The clay is best suited to being carved or incised without breaking as well as being trimmed, or applying slip and underglaze. The leather-hard stage can be further refined as soft leather-hard, leather-hard, and dry leather-hard.

**Liner glaze:** Glaze that is applied to "line" the interior of a functional vessel.

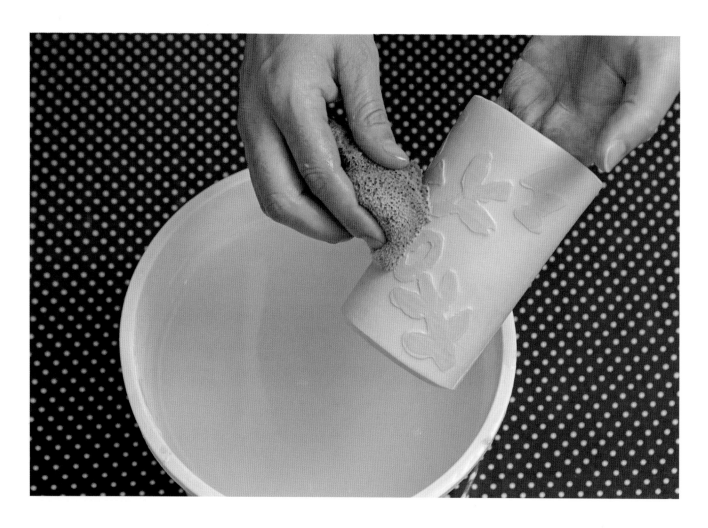

**Low fire:** Work fired below about 2000°F (1100°C). Many clays and glazes are designed for this, and it is popular among schools and hobbyists. Low firing uses less energy, and generally the clays and glazes are more forgiving of temperature variations and other problems.

**Mid-range fire:** Commonly associated with a cone 5 to 8 firing range. Ceramists use mid-range firings to achieve the durability of high-fire work in a more energy-efficient way. Mid-range firing has become more commonly used in both electric and gas kilns.

**Mishima:** A surface decoration that includes inlaying a slip or an underglaze into an incised or carved line on the surface of greenware.

**Motif:** A distinctive and recurring form, shape, or figure in a design.

**Oxidation:** A kiln atmosphere that has enough oxygen in it to completely consume the fuel as it burns and the flames move through the kiln. It also describes clay bodies and glazes that are developed for oxidation firing.

**Oxides:** Oxidized metals such as cobalt, iron, and copper that are used to color ceramic slips, glazes, and underglazes. For example, oxidized iron is rust or iron oxide.

**Pinhole:** A small hole in the glaze surface. The presence of a pinhole typically means the glaze is not entirely sealing the ceramic surface. Glaze contains a certain amount of volatile materials and will undergo some bubbling as the materials burn off during the firing process. If the off-gassing continues as the glaze cools, the result can be pitting and pinholing.

**Porcelain:** A strong, vitreous, translucent ceramic material, bisque-fired at a low temperature (cone 06 to 08), and the glaze is then fired at a mid/high temperature range (cone 6 to 10).

**Pottery plaster:** The best material available for making plaster bats, wedging boards, and working molds.

**Reduction:** A lack of oxygen in a kiln firing, which makes the fuel burn inefficiently and the kiln fill with free carbon. The free carbon atoms will aggressively grab up any oxygen atoms they can find. When the carbon reduces the amount of oxygen in the clay and glaze molecules, the colors and textures of the clays and glazes can change.

**Sgraffito:** A surface decoration technique in which a layer of slip or underglaze is carved through or incised to reveal a ground of contrasting color.

**Slip:** A liquefied suspension of clay particles in water. Slip is usually the consistency of heavy cream and is applied decoratively to wet or soft leather-hard greenware. Slip may also be used for casting clay in plaster molds. Casting slip almost always has added ingredients to keep it in a uniformly consistent suspension until dry.

**Slump:** The term used to describe when a ceramic form shifts and moves in the making, drying, or firing process.

**Stoneware:** A hard, opaque, vitrified ceramic ware that typically contains some grog and ball clay, making for a buff-colored ware. Fired to a high temperature.

**Underglaze:** Used to create surface designs and patterns underneath glaze. Underglazes can be used under clear or colored transparent glazes. Underglaze as a descriptive term can include slips, engobes, and stains, as well as the most common use: commercial products that are marketed as underglazes.

**Vitrified:** Clay and glaze fired to their hardest point or maturity, making the clay body impervious to water.

# ARTIST DIRECTORY

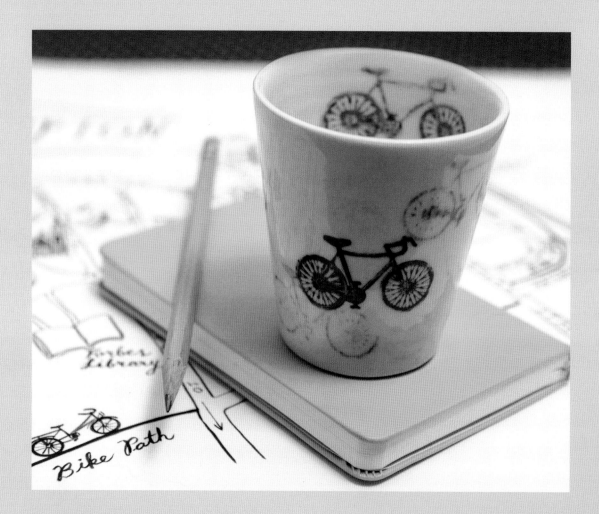

**Heather Braun-Dahl** www.dahlhausart.com

**Sunshine Cobb** www.sunshinecobb.com

**Chandra DeBuse** chandradebuse.com

**Maria Dondero** mariadondero.com

**Rae Dunn** www.raedunn.com

**Heather Mae Erickson** heathermaeerickson.com

**Diana Fayt** www.dianafayt.com

**Meredith Host** meredithhost.com

**Kristen Kieffer** kiefferceramics.com

**Hannah Niswonger** www.hnclay.com

**Brooke Noble** www.facebook.com/nobleclaygirl

**Doug Peltzman** www.dougpeltzman.com

**Sandi Pierantozzi** sandiandneil.com

**Brenda Quinn** www.brendaquinn.com

**Kari Radasch** kariradasch.com

**Alex Reed** alexjreed.com

**Andy Shaw** shawtableware.com

**Evelyn Snyder** www.kscopepottery.com

**Adero Willard** aderowillard.com

# ABOUT THE AUTHOR

The daughter of a painter and an organic dairy farmer, Molly Hatch was raised to be creatively industrious. She uses her imagination and love of drawing to make everything from her well-known idiosyncratic ceramics to quirky pen-and-ink drawings. Molly's craft is finely honed, and her designs are whimsically literal and pop-culturally on point.

Working from her basement studio, Molly began her career as a studio potter in 2008. Her formal education in ceramics and drawing resulted in the development of her signature style. Molly's career as a studio potter making contemporary ceramics inspired by history quickly gained momentum and grew to a career as an artist designer. Her designs have expanded beyond tableware to a range of lifestyle products, and she is actively growing collections of home goods to bring her modern yet traditional designs to the contemporary home.

*To read more about Molly and see more of her work, visit* **www.mollyhatch.com** *and* **mollyhatchstudio.com**.

# ABOUT THE PHOTOGRAPHER

Thea Coughlin began her career as a teacher and is now a successful photographer living in upstate New York with her son and husband.

In addition to her portrait and commercial photography business, Thea's work has been featured in numerous magazines, including *Country Living*, *Somerset Studio*, *Where Women Create*, and *Healthy Life*. When Thea is not photographing commercial jobs, working with clients, or teaching photography, you may find her hiking in the woods with her family, climbing trees, or laughing with those she loves.

To find out more about Thea and see more of her work, visit **www.theacoughlin.com**.

# ACKNOWLEDGMENTS

|||||||||||||||||||||||||||||||||||||||||||||||||||||||||||||||||||||||||||||||||||||||||||||||

This book would not have been possible without the guidance and helping hands of many throughout the process. Thank you to my husband and family for supporting me through many late nights and weekends of extra work to make this book possible. I would like to acknowledge my editor, Mary Ann Hall, for all of her support and guidance through the publication and writing process; I couldn't have done it without her step-by-step support. This book had much aesthetic guidance from my friend and colleague Asya Palatova, and her generous support made all the difference—thank you! Thea Coughlin's experience and gorgeous photos made creating this book a total pleasure. I couldn't imagine working on this with anyone but Thea as my photographer. I would also like to thank the artists who contributed to this book. And last, but certainly not least, thanks to Elena Zachary. Your hard work and ability to finish my thoughts made this book fun to work on, and the photo shoots just simply wouldn't have been a success without you there!